# DC

# WOMEN
## OF ACTION

# DC WOMEN OF ACTION

BY SHEA FONTANA

CHRONICLE BOOKS

SAN FRANCISCO

Library of Congress Cataloging-in-Publication Data is available.

ISBN 978-1-4521-7394-8

Manufactured in China.

Written by Shea Fontana.
Design by Jon Glick.
10 9 8 7 6 5 4 3 2 1

Chronicle books and gifts are available at special quantity discounts to corporations, professional
associations, literacy programs, and other organizations. For details and discount information,
please contact our corporate/premiums department at corporatesales@chroniclebooks.com or at
1-800-759-0190.

Chronicle Books LLC
680 Second Street
San Francisco, California 94107
www.chroniclebooks.com

"SHE SHALL GO FORTH TO FIGHT FOR LIBERTY AND FREEDOM AND ALL WOMANKIND!"

—**Hippolyta**, *All-Star Comics*, #8 (1941)

# CONTENTS

# INTRODUCTION

**SUPERHEROES INSPIRE US.** Their capes billow like flags, signaling selfless valor and courage. Since these archetypical cape-and-tights heroes first appeared, they've epitomized the best of humanity, showing a world where good always wins against evil and light always overcomes darkness. Among the heroes of the DC Universe are some of the most iconic and impactful female characters in the world. In this book, we'll highlight the finest, from enduring icons like Wonder Woman, Lois Lane, and Black Canary to relative newcomers like Thunder and Lightning. And since a hero's strength is measured by the villains she overcomes, we'll also be looking at some of the wickedest Super-Villains who wreak havoc across Gotham City, Metropolis, and Themyscira.

Women have been a part of the comics industry from the beginning, both on the page and behind the scenes. DC's *New Comics* #1 (1935) featured illustrations from Emma C. McKean, who was the first woman credited in mainstream comics, and the later 1930s included contributions from artist Serene Summerfield and writer/editor Connie Naar.

On the character side, though several female characters were featured in the early years of comics, none were as impactful as Wonder Woman, who burst into comics in 1941. She was progressive, empowered, and bold, setting the bar for the multitudes of female heroes who would follow in her boot-steps. From that early high standard, DC has continued to publish some of the most diverse and boundary-pushing characters in comics. With characters like Jessica Cruz, a Mexican American Green Lantern who battles an anxiety disorder, and Oracle, the physically disabled

alias of Barbara Gordon who led the Birds of Prey, the DC Universe is filled with women who prove that everyone can be a hero.

While female characters fought for justice on the page, the generations of women who have worked in comics emulated their costumed counterparts and became beacons of hope, inspiring the little girls who saw their names in the comic book credits. In this book, we'll profile some of the most historically significant, such as Dorothy Woolfolk, who started her career as a comic editor in 1942, and artist Ramona Fradon, best known for her work on Aquaman and as co-creator of Metamorpho. And the cast of important female creators contributing to the DC Universe is ever-expanding. In particular, the new young reader imprints DC Ink and DC Zoom have welcomed a number of superstars of children's and young adult publishing, such as Danielle Paige, Kami Garcia, Lauren Myracle, Mariko Tamaki, Laurie Halse Anderson, Melissa de la Cruz, and Meg Cabot.

The legacies of people and characters profiled in this book live on. Through my work on *DC Super Hero Girls*, I've been able to see empowered kids who are growing up reading superhero comics where equality and gender parity is the norm. I have hope that these comic-loving kids will continue to demand greater diversity in their entertainment and in their lives—and that they will lead society to an unprecedented pinnacle where we will soar.

Superheroes have always inspired us. And they continue to inspire us to reach new heights of diversity, representation, and gender equality.

THEMY

SCIRA

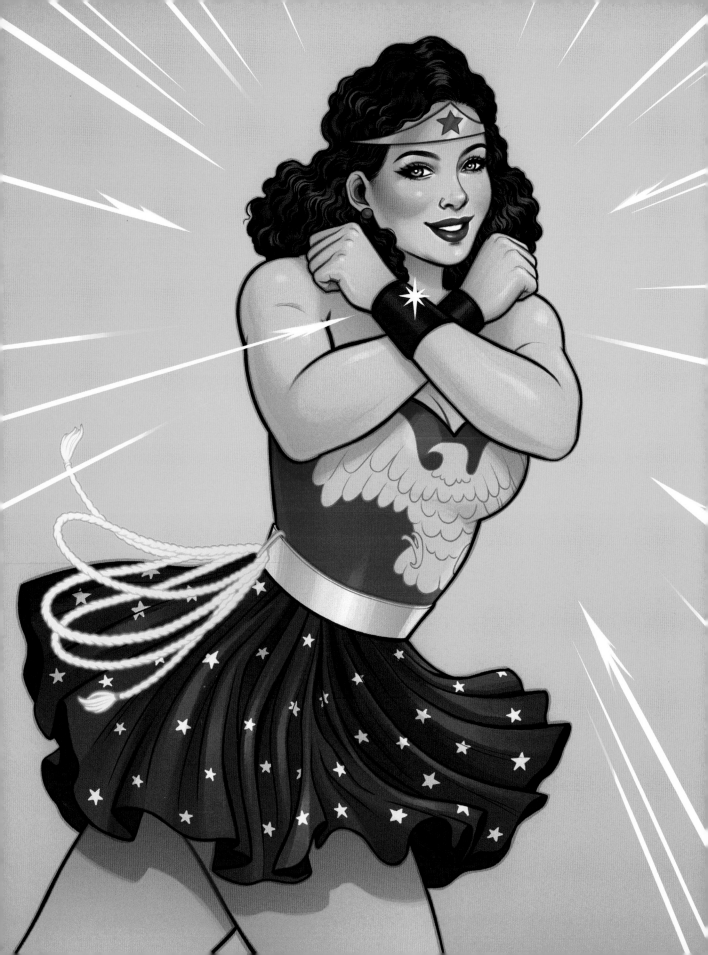

# WONDER WOMAN

"DON'T KILL IF YOU CAN WOUND, DON'T WOUND IF YOU CAN SUBDUE, DON'T SUBDUE IF YOU CAN PACIFY, AND DON'T RAISE YOUR HAND AT ALL UNTIL YOU'VE FIRST EXTENDED IT." —**Wonder Woman**, *Wonder Woman #25 (2008)*

**IT ALL STARTED WITH WONDER WOMAN.** As the seminal female Super Hero, Wonder Woman did everything that her male counterparts did, and for much of her publishing history, she did it while wearing high heels. She may not have eye lasers or X-ray vision, but she is still every bit as much of a hero as Superman while simultaneously breaking the bonds of patriarchy and carrying the mantle of feminist icon. Like many women who find themselves in the spotlight, she has been held to a higher standard, expected to be the ideal of heroism and a proxy for womankind—and to do it all in twenty pages, twice a month.

While Wonder Woman's superpowers were similar to the other popular heroes of her time, her origin story differed from the usual trope. Unlike many of her predecessors for whom tragedy was the impetus of their heroic identities, Wonder Woman came to superheroism from a different perspective—she chose to be a hero because of her love for humanity and her desire to help. "She is most emotionally accessible because she makes herself the most emotionally available," said Nicola Scott, artist on multiple Wonder Woman books, as she recounted why she loves the character. "She's everyone's big sister, everyone's mom, everyone's friend."

Born on the all-female island paradise of Themyscira (in some versions called Paradise Island and the Amazon Isles), Diana grew up surrounded by love, kindness, and sisterhood. By rule of the Greek gods who protected Themyscira, males were banned from the island; and when a stranger named Steve Trevor crash-lands there, Diana defies the law, choosing to aid him instead of letting him face the death penalty. She helps him find his way back to his country, even though that means sacrificing her ability to return to her beloved mother and home. As Diana enters the world of man, she accepts the alias of Wonder Woman and uses her unique arsenal—a Lasso of Truth, bulletproof bracelets, superhuman strength, and super-speed—to help humanity by bringing justice and ending war.

The character of Wonder Woman has many sides to her, embodying both the power of a warrior and a heart for peace. "I deplore violence—I prefer to reason with my enemies," she says in 1974's "The Twelve Labors" story arc, in which she proved herself worthy of rejoining the Justice League.

"I think her femininity is not in contrast with strength. Strength is not only a masculine characteristic," said Mirka Andolfo, artist on *Wonder Woman #26–27* (2017). This balance of strength and femininity has been a part of the character since she was created by William Moulton Marston and first appeared in comics in 1941. As a prominent psychologist, Marston's work studying the human mind was influential in his creation of the fierce Amazon hero. Seeing comics as a way to promote his message of female empowerment, he created a hero who could triumph over humanity's troubles. As he wrote in the first appearance of Wonder Woman, "At last, in a world torn by the hatreds

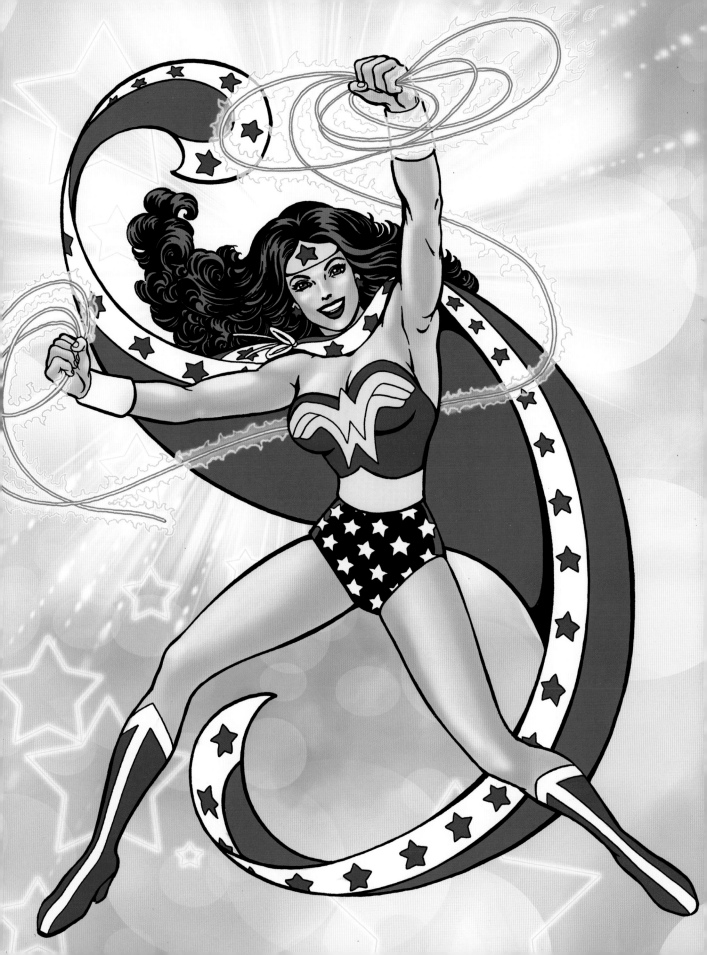

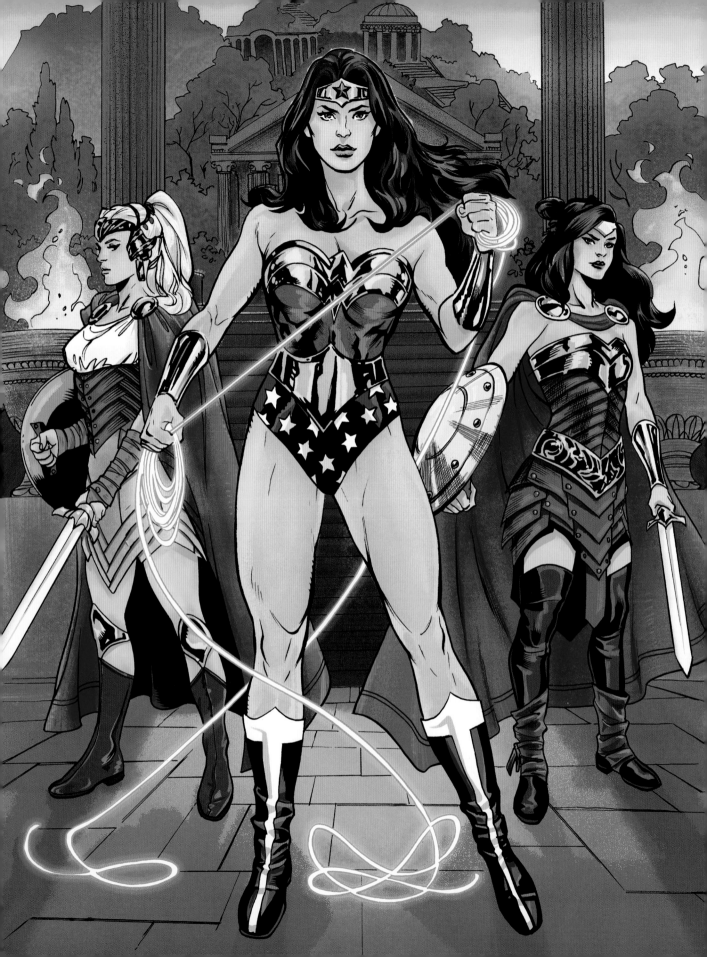

and wars of men, appears a woman to whom the problems and feats of men are mere child's play." Through this character, he would influence youth and set a new paradigm for female characters.

The *Wonder Woman* title promoted female empowerment beyond its fictional star. Early *Wonder Woman* comics featured "Wonder Women of History" segments, which highlighted real women of historical importance like Susan B. Anthony, Helen Keller, and Sojourner Truth. Additionally, the Wonder Woman series has been an oasis for female talent in the comic industry. Joye Murchison Kelly started working on the Wonder Woman book in 1944 and ghostwrote many Wonder Woman stories over a three-year period while Marston's health declined. In the following decades, several of the industry's top female talent would contribute to the title, including Trina Robbins, Jill Thompson, Mindy Newell, Dann Thomas, Gail Simone, and G. Willow Wilson.

The beauty of superheroes who have stood the test of time is that they take on a life of their own, coming to represent evolving ideals. They mean different things to every comic reader, and allow redefinition by each generation while remaining true to their core DNA. The best heroes become magic mirrors for us, reflecting just what we need at the right moment. They are prisms through which our current culture is filtered into easily digestible, Ben-Day dot swaths of cyan, magenta, yellow, and black. This is especially true for Wonder Woman, who becomes a surrogate for what people want to see in her. She's constantly being reframed into the hero we need right now.

Wonder Woman's pliability is evident in her resurgence in the 1970s. After Marston's *Wonder Woman* run, during the 1950s and '60s, Diana Prince took on a variety of identities and roles as creators struggled to

recapture the resonance of her early character portrayals. In an effort to make her more relatable, Wonder Woman lost her superpowers and instead dabbled in modeling, acting, babysitting, and running a fashion boutique while pining for Steve Trevor, who was murdered by an assassin's bullet (of course, he'd later return).

In 1972, Wonder Woman reemerged, brighter than ever, becoming the face of the feminist movement when she was featured on the inaugural cover of *Ms.* magazine. This took her from her first-wave feminist roots (which centered around women's suffrage) and transformed her into an envoy of the more progressive principals of second-wave feminism, including embracing civil rights and fighting to reduce inequalities. The pro–women's liberation version of Wonder Woman started in pop culture, outside of her official DC publications. As the public perception of Wonder Woman shifted, publishing followed. In the comics of the mid-1970s, she transformed into an empowered Super Hero who is reinstated in the Justice League and who shows off her feminist leanings by opening car doors for men, insisting on paying for her own dinner during a date, and excelling as an aide at the United Nations.

Since her first appearance, Wonder Woman has broken records and made history at every turn. She was the first female Super Hero to headline a major comic book, the first female comic book Super Hero to have her own TV series, the headliner of the longest running comic series starring a woman, and, with the 2017 *Wonder Woman* film, she was the first female Super Hero to crush $800 million at the box office, breaking the record for the top-earning Super Hero origin story.

Wonder Woman's adaptability combined with her mainstream success has made her the most iconic female character in the world.

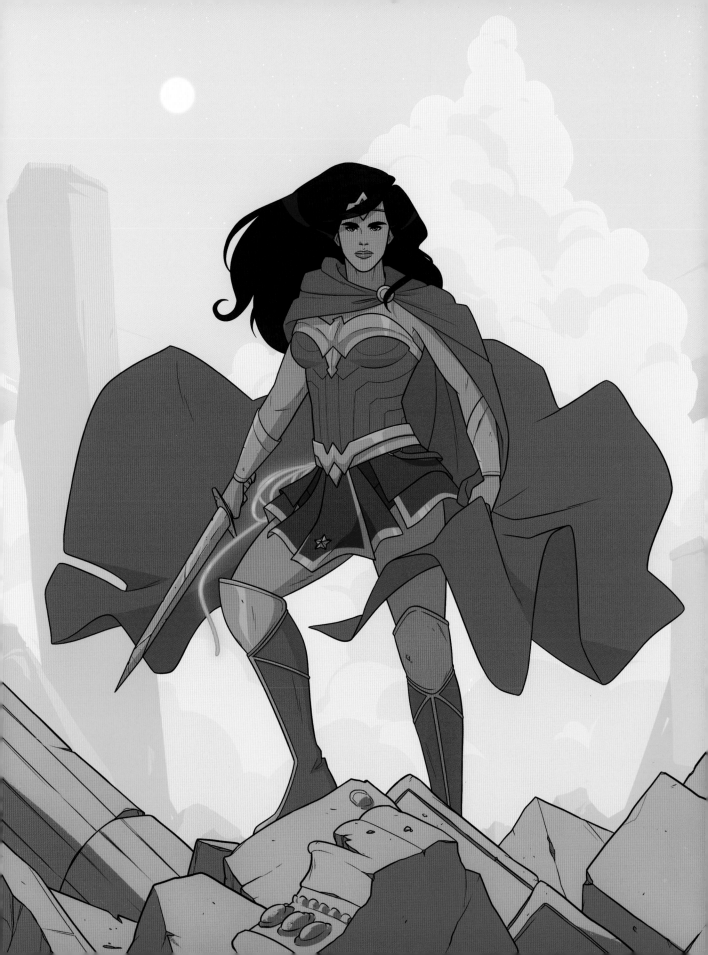

From the red cape, boots, and spangled bodysuit made famous by Lynda Carter to the armored bodice of Gal Gadot to the practical star-striped pants of her teenage version in *DC Super Hero Girls*, her costume is one of the most emulated by girls and women across the globe. "My favorite character when I was a kid has to be Wonder Woman. The bracelets, you know," said Amy Chu, writer on *Wonder Woman '77* (2015), a contemporary comic book series adapted from the 1970s TV series. Nicola Scott echoed Chu's sentiments: "She had great accessories, with her bracelets, her tiara, and her lasso." Around the world, countless kids have been empowered by her presence. If Wonder Woman could do it, they too could fly from the peak of their couch cushions, hold back the forces of villain-playing siblings, and save the day. By showing the world that anyone could be a hero, all types of kids were able to project themselves onto her. She defied boundaries with her universal appeal.

Vita Ayala, who wrote a story for *Wonder Woman Annual #1* (2017), recalled, "I am Puerto Rican. When I first remember seeing Wonder Woman, I was about six or seven. My mom used to take my brother and me to this Korean bodega down the block, and they had a spinner rack of comics. I remember seeing her on the cover of her book, smiling, looking heroic. Her costume—the star-studded short-shorts, the bright halter top with the gold on it, the bangles and tiara—looked like something that I had seen someone in my family wear. I also have a cousin named Diana. Heck, she even looked like one of my cousins! I asked my mother who she was

and where she was from, and she told me her name and that she was from an island of powerful, intelligent, beautiful women. Well, that cinched it—clearly she was from my island."

Halfway across the world in Australia, Nicola Scott had a similar experience, relating Wonder Woman's family to her own. "She spoke to me because I come from a family of big, loud women. Her heritage made sense to me."

Nearly ten thousand miles away in Italy, Mirka Andolfo was also drawn to Wonder Woman. "She is a symbol of universal justice: her heart is stronger than her muscles," said Andolfo.

And in the tiny, rural Utah town where I grew up, I saw Wonder Woman as the equalizer, proof that girls were independent, strong, and capable. Long before I could fathom that I would ever officially write her, she inspired in me a confidence that I could do anything that my three older brothers could.

Wonder Woman's power to inspire resonates around the world. She is the hero for everyone.

# HIPPOLYTA

"WHATEVER FATES WE ARE TO MEET, WE SHALL FACE THEM TOGETHER . . . AS SISTERS . . . AND AMAZONS!" —**Hippolyta**, *Wonder Woman* #22 (1988)

**HIPPOLYTA REIGNS SUPREME AS THE MONARCH OF THEMYSCIRA,** a mighty warrior, and the nurturing mother of Wonder Woman. Based on the Amazon queen from Greek mythology, DC's Hippolyta has developed into a modern woman who proves that motherhood and strength go hand in hand.

Being a mother is one of Hippolyta's greatest powers. While the majority of heroes throughout DC history are generally portrayed as childless, or their stories tend to focus on their pre–child-rearing years, Hippolyta embraced motherhood as a complement to her heroism. In the original comic continuity, she desired a daughter so much that she formed a baby out of clay and, with a little help from the Greek gods, brought Diana to life with her love. In addition to Diana, throughout the years Hippolyta expanded her diverse "family" to include Nubia and Donna Troy, who becomes the first Wonder Girl, as well as other characters like Artemis, the Furies, and Cassie Sandsmark, the second Wonder Girl.

Hippolyta is at her most interesting when her duties as queen conflict with her instincts as a mother. After a disguised Diana wins a tournament to prove herself the destined ambassador who will return Steve Trevor to the world of men, Hippolyta is forced to choose between her queenly obligations and protecting her daughter from eternal banishment from Themyscira. She ultimately chooses to let Diana follow her heart and fulfill her destiny, even if that means mother and daughter will never be together again. Hippolyta's heartbreak becomes humanity's boon as her daughter becomes Wonder Woman and spreads the love and peace taught to her by her mother.

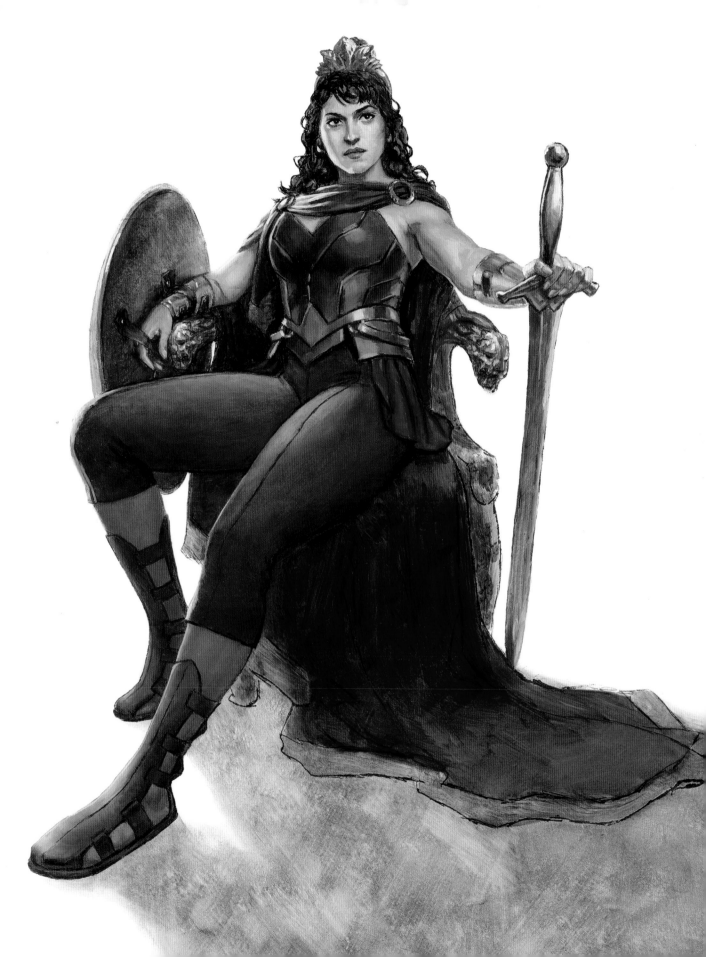

# ETTA CANDY

---

"COME ON, WONDER WOMAN! LET'S FIGHT THESE FATHEADS!"

—**Etta Candy**, *Wonder Woman* #1 (1942)

---

WOO WOO! IT'S ETTA CANDY! With her quirky catchphrases and brazen assurance, Etta has been a constant companion, welcome sidekick, and formidable fighter since bursting onto the pages of *Wonder Woman* shortly after Diana herself.

From her debut, Etta didn't look like other women in comic books. She was not an athletically slender Super Hero nor a wispy love interest—and neither archetype interested her. In her initial stories, curvaceous Etta was happy with her own body. When introducing her friends, she refers to them as "One hundred beautiful athletic girls—like me!" In *Sensation Comics* #2 (1942), through some Super Hero magic, Etta is transformed into Wonder Woman's doppelganger, but she can't wait to get back to her own body. "I've had no candy since I got into this skinny body of yours and I'm fed up!" snaps Etta.

Not only did these stories feature an Etta who blossomed with body positivity, she also was a hero in her own right, bravely leading a commando unit called the Holliday Girls who battled the Nazis and saved Wonder Woman on multiple occasions. This first version of Etta was a vivacious fighter. She's seen knocking out a Nazi soldier with a pair of pliers, using a sword to slash through chains that bind Wonder Woman, and throwing punches at anyone who got in her way. With righteous fury, plenty of moxie, and a mean left hook, Etta was an integral part of Wonder

Woman's success. Even without superpowers, she bravely and enthusiastically faced danger.

Etta Candy represented the attainable, yet still aspirational, character. We mere humans had no hope of flying or finding a pair of bulletproof bracelets, but we could imitate Etta Candy's strength as she stood up to bad guys, had confidence in herself, and nourished her utterly human love for delicious candy.

The character of Etta began as a kooky, plump blonde who becomes Wonder Woman's friend and aids her during her escapades, but like many of her peers, her backstory and appearance would change throughout the years. In the 1960s, Etta fared no better than Wonder Woman, who was floundering without powers. This Etta was insecure, meek, and weight-conscious and quickly faded from Wonder Woman's life. But a more empowered Etta would return to the book twenty years later as Lieutenant Candy, a capable Air Force officer and love interest of Steve Trevor.

The *New 52* comic line saw another major shift in Etta's portrayal when she was rebooted as an African American naval officer who joins the covert A.R.G.U.S. organization and aids with Wonder Woman's missions. In the Rebirth stories, Etta takes on the role of Commander Candy, Steve Trevor's military superior.

When writing the *Wonder Woman* comic book (issues #26–30, 2017), I was inspired by the early version of Etta combined with her empowered portrayal in earlier Rebirth stories. I focused my arc on writing about the friendship between Wonder Woman and Etta, ensuring that they were equals in their bravery, boldness, and confidence. Etta is not submissive to Diana—she fights beside her, has moral disagreements with her, and is explicitly trusted by her.

Etta Candy breaks the mold, being twice as courageous and capable as your average hero. She doesn't need anyone's approval because she believes in herself. Etta embraces her strengths, defies expectations, and enjoys herself while doing it. As she said when she sliced through shackles that were binding Wonder Woman, "Woo woo! This is easy as cutting chocolate fudge!"

# WONDER GIRL

"GROWING UP, I WAS COMPLETELY OBSESSED WITH DONNA TROY. THE IDEA OF HAVING WONDER WOMAN AS YOUR BIG SISTER SEEMED PRETTY AMAZING TO ME; AND ALSO I WAS CRAZY ABOUT HER COSTUME." —Lilah Sturges, comics writer

WONDER GIRL IS A PSEUDONYM used by multiple characters throughout DC's history. All versions have ties to Wonder Woman, though in some iterations she is Wonder Woman's sister, in others she is Wonder Woman's protégé, and initially she was even Wonder Woman herself as a teenager. Donna Troy and Cassie Sandsmark are the two most well-known characters to take on the identity of Wonder Girl. During their runs as Wonder Girl, both Donna and Cassie join the Teen Titans.

The character of Donna Troy was created in 1965, and through the years the creatives working on her have rewritten her backstory from an orphaned human girl adopted into Wonder Woman's family to a golem created to destroy Wonder Woman. With the 1980s' version of Wonder Girl, Donna became a wunderkind who was a superhero, fashion icon, and successful photographer. She was a girl who could do it all and acted like the perfect sister while doing it. "Donna Troy, especially in the red jumpsuit, is my favorite Teen Titan of all time," said Nicola Scott, artist on *Teen Titans*. As Donna aged, she changed aliases multiple times, being known as Troia and Darkstar, among others.

After several decades of Donna Troy, Cassie Sandsmark was created to fill the Wonder Girl boots. In the *New 52* continuity, Cassie's powers come from her dad's side—she's a daughter of a demigod and granddaughter of Zeus, which makes her Wonder Woman's niece.

As an accessible young superhero, Wonder Girl sparked the imagination of many fans who aspired to take on their own teenage troubles with the maturity and skill of Wonder Girl. She looked like a rock star who just walked off the set of a music video; and even though she was young, Wonder Girl was in control, competent, and kind. She is the type of hero that readers wanted to be.

# THE CHEETAH

"THERE IS NO BARBARA! THIS IS WHO I AM!"

—**The Cheetah**, *Wonder Woman #21 (2017)*

AS WONDER WOMAN'S ARCHNEMESIS, the Cheetah is queen of the Rogues Gallery jungle. She has been clawing her way to glory since her debut in *Wonder Woman #6* in 1943. In this initial incarnation, the catty baddie was the alias of Priscilla Rich, a wealthy American socialite. Spurred by her jealousy of Wonder Woman, Priscilla gives in to the evil lurking inside her and becomes The Cheetah. Determined to tear the spotlight from Wonder Woman and put it on herself, Priscilla unleashes her plot to take over Paradise Island, but meets her defeat at the hands of the angry Amazons.

Since Priscilla Rich, there have been several incarnations of the Cheetah, each with a different backstory. In modern stories, she is Dr. Barbara Ann Minerva, an archeologist who is transformed into the Cheetah. The more recent versions of the character have expanded her powers to include super-speed, super-strength, and catlike enhancements. This cat is a worthy adversary to the Amazon warrior.

The Cheetah excels most as a challenge not only to Wonder Woman's physical strength, but also to her sense of justice. Dr. Minerva herself isn't always portrayed as strictly villainous, but rather a woman possessed by an evil spirit, lacking the ability to free herself from the overwhelming force. This version of her nemesis forces Diana to examine her methods and morality. Dr. Minerva and the Cheetah are physically inseparable, but should Dr. Minerva be forced to pay for the Cheetah's crimes? Wonder Woman struggles with how justice can properly be served in the unjust situation. In the Cheetah, Wonder Woman finds a complex archnemesis who antagonizes her on every level.

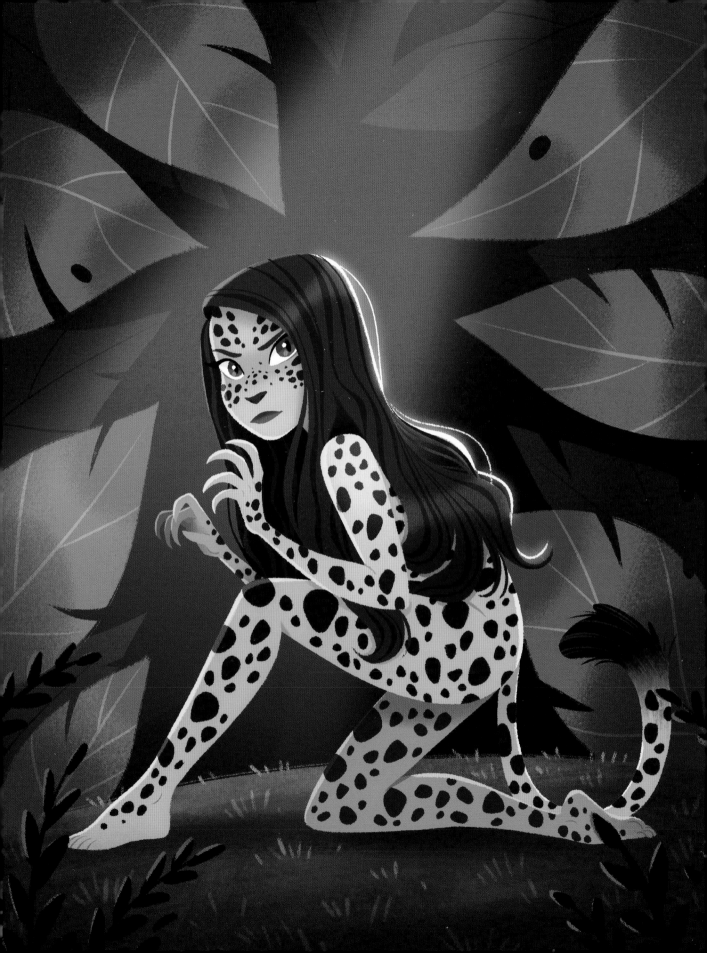

# CIRCE

"I AM YOUR REFLECTION IN A WARPED MIRROR. THIS WORLD IS NOT BIG ENOUGH FOR BOTH OF US." —**Circe**, *Wonder Woman #19* (1988)

**CIRCE'S ANCIENT MAGIC** makes her one of the most powerful foes in DC lore. Like many of the characters created for early *Wonder Woman* comics, Circe finds her namesake in Greek mythology, though our devilish DC dame is more powerful than her ancient counterpart. Her near limitless magic and apparent immortality are rounded out with a healthy dose of manipulation and seduction powers, which serve her well as she faces some of the strongest heroes in the universe.

As a mercenary, she lends her talents to those like Lex Luthor, who can give her what she wants. She can also be summoned through magic means, which is how Veronica Cale acquires Circe's assistance in the storylines that followed the Rebirth event. Though she is often in opposition to Wonder Woman, she has also helped the hero under the right circumstances. Devious Circe is playing an eternal game, switching sides whenever she sees fit.

Though her physical appearance has morphed throughout the years, Circe is always ravishing, wielding her good looks like other witches wield wands. With her magic mirror and wicked glamour, Circe makes being bad look real good.

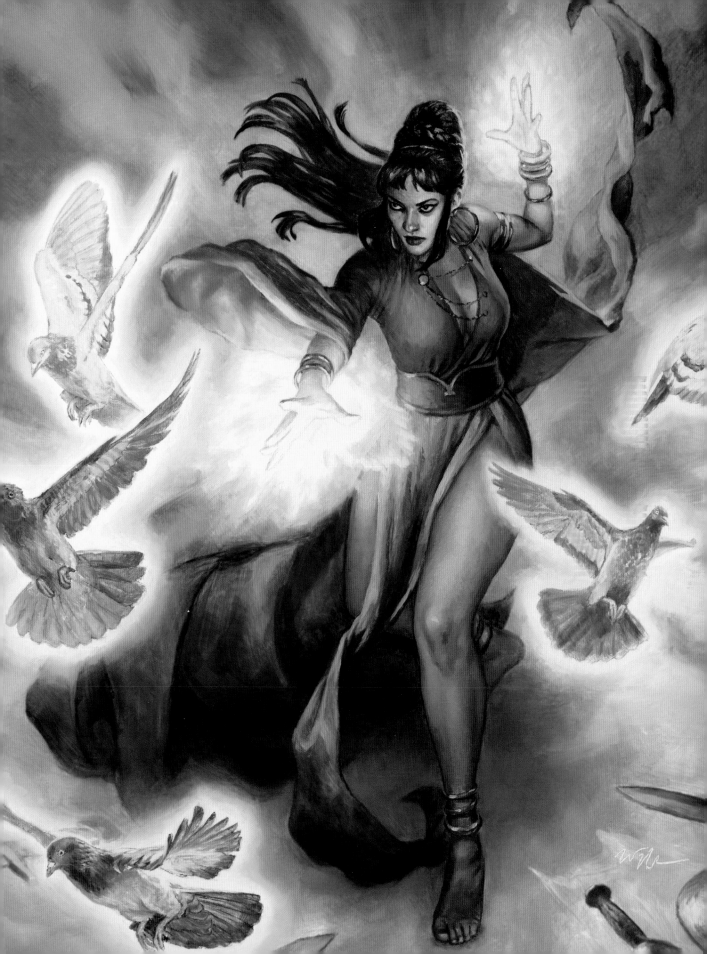

METRO

# POLIS

# SUPERGIRL

"TO ME THE BEST PART OF WRITING SUPERGIRL IS THAT SHE IS A CHARACTER WITH SUCH HEART AND HOPE. SHE IS ACTUALLY SUPER. SHE FLIES AND CAN CRUSH VERY BIG THINGS WITH VERY LITTLE EFFORT . . . THAT'S NOT TO SAY SHE DOESN'T ALSO MAKE MISTAKES, OR MESS UP. ACTUALLY, IT'S GOOD THAT SHE MESSES UP. IT LETS YOU KNOW THAT EVEN SUPERHEROES WITH THE BEST OF INTENTIONS AND INCREDIBLE POWERS SCREW UP SOMETIMES. BUT THEY'RE STILL SUPER." —**Mariko Tamaki**, writer, *Supergirl: Being Super* (2017)

SUPERGIRL CAN DO IT ALL—not even her Kryptonian heritage gets in the way of her being an all-American girl. She has one of the most tragic pasts in the DC Universe, but remains optimistic and is a beacon of hope for others. Even though she was originally meant to be a mere sidekick, with her intriguing layers of duality she has soared to become one of the biggest stars in Metropolis.

When Kara Zor-El of the planet Krypton is forced to leave her home and seek a new life across the universe, she never expected to become a solar-powered Super Hero and take on the mantle of Supergirl. First introduced in 1959's *Action Comics* #252, Supergirl was created as the female counterpart to Superman, positioned as Superman's teenage cousin.

With powers equal to her Super Hero cousin's, Supergirl can absorb the energy of the yellow sun and transform it into superpowers. She has super-strength, flight, invulnerability, increased stamina, freeze-breath, and enhanced senses, including X-ray vision and super-hearing. She also has Superman's vulnerability to Kryptonite—a chunk of the green rock can render her helpless. Although she shares Superman's powers, young

Supergirl lacks her cousin's experience and needs the veteran hero's training and guidance. Wearing a costume that is the skirted version of his, she starts her Super Hero career as his trusty sidekick.

Supergirl's "perky partner" demeanor belies her heartbreaking back-story of losing her family and home planet in the destruction of Krypton. When Kara Zor-El and Kal-El were blasted from Krypton in their individual spaceships, Kara was older than Kal-El—she was a teenager and he was an infant. However, the paths of their ships diverge, and Kara gets stuck in an ageless slumber in a dimension known as the Phantom Zone, while Kal-El zipped toward Earth. When Supergirl is freed from the Phantom Zone and appears on Earth a few decades later, she is still a teenager with fresh memories of Krypton, while baby Kal-El never remembered his time on Krypton and has grown into the Earth-assimilated adult Clark Kent.

In her 1970s stories, Supergirl grows up, graduates from college, and works at a local news station, all of which fit the model of the other successful female characters at the time. However, Supergirl wouldn't enjoy adult life for long; following the *Crisis on Infinite Earths* series of the mid-1980s, when many of the DC Multiverses were merged into one universe, this Supergirl was erased and Superman was positioned as the sole survivor of Krypton. During that period, non-Kryptonian versions of Supergirl appeared in comics.

For years, the Kryptonian Supergirl was stuck in an editorial Phantom Zone, but she reappeared in comics in 2004. This new version of Supergirl had more agency, a life beyond being Superman's sidekick, and her own distinct place in the DC Universe.

In both her early and contemporary iterations, Supergirl's youth set her apart from the adult women who populate many superhero comics.

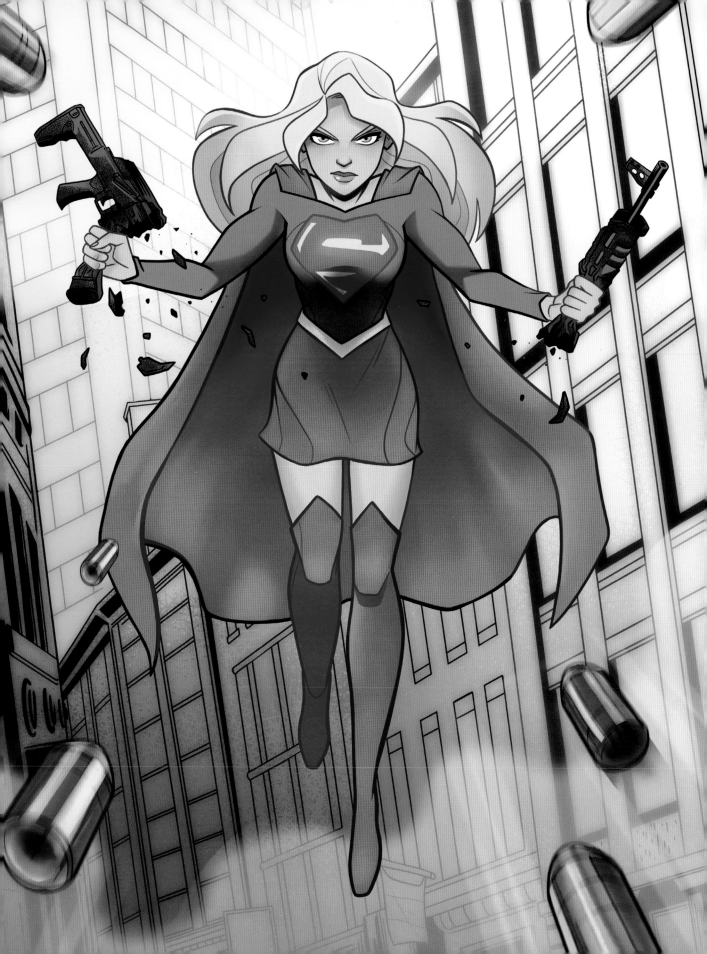

Not only does Supergirl contend with super-villain invasions and save-the-day scenarios, but she also must deal with being a teenager. She is inexperienced in both super-heroics and Earth culture. As a fish-out-of-water thrust into high school life, Supergirl's problems are relatable to the younger readers of her adventures.

Agnes Garbowska, artist on *DC Super Hero Girls*, recalled: "Supergirl was my entryway into the DC Universe. A friend of mine growing up had an older brother and when he was away we would sneak into the basement where his comic collection was and as carefully as possible read his comics. That is where I discovered Supergirl. I still remember seeing the cover of her holding the skateboard and the one of her standing in the flames and asking myself, 'Who is she?! I must know more!' Once I started reading, I ended up running out and buying more Supergirl comics since I wanted to continue reading about her adventures."

In addition to her teen adventures, Supergirl's emotional vulnerability draws readers to the character. With the trauma of her planet's demise still fresh in her mind, she tries to be a hero while mourning the loss of her home, her lifestyle, and everyone she knew. She experiences survivor's guilt and reveals a relatable rawness as she feels and processes the extent of her loss. Despite her grief, Supergirl embodies a youthful resilience and brilliant optimism. She doesn't become defined by her loss, as she is able to retain her positivity even in the darkest moments.

With her Kryptonian physiology, Supergirl is the most super-powered girl on Earth. As such, her help has been sought by several crime-fighting teams, including the Legion of Super-Heroes, Justice League, the Titans, and multiple partnerships with Wonder Woman, Batgirl, and the Flash.

In 1984, she soared off the comic page and onto the big screen with *Supergirl*, the first feature film based on a female superhero. With Helen Slater taking on the role of a teenaged Supergirl, the movie introduced a new fanbase to the character. Three decades later, the Kryptonian hero would hit the small screen with the *Supergirl* TV series, starring Melissa Benoist. Benoist is equally adept as the high-flying hero and in her secret identity of Kara, the charming girl-next-door with an easy smile and helpful heart. The character is sociable and kind, and her genuine concern for others goes beyond how she relates to people as a superhero. Even when she's not flying off to stop invading alien armies and save the entire planet, she's willing to help in small ways to make one person's day a little brighter.

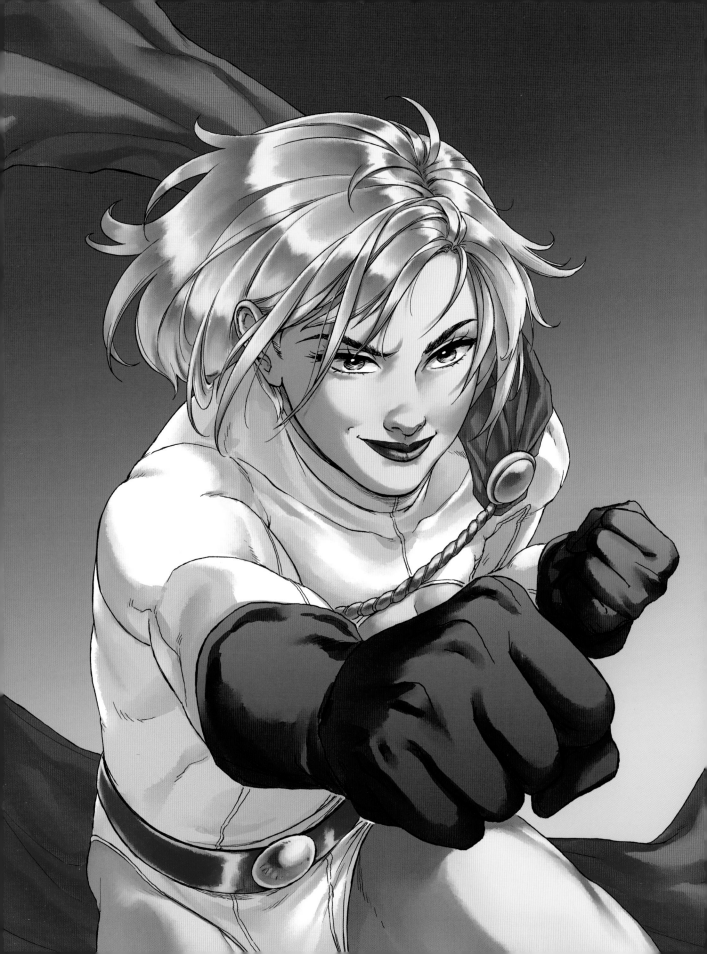

# POWER GIRL

"WHAT I LOVE MOST ABOUT POWER GIRL IS HOW INDEPENDENT SHE IS. SHE'S A BUSINESSWOMAN AND SHE INSISTS ON SUCCEEDING ON HER OWN TERMS. I LOVE THAT HER SECRET IDENTITY IS SOMETHING SHE TAKES JUST AS SERIOUSLY AS HER HEROICS." —Lilah Sturges, writer, *Power Girl* and *JSA All-Stars*

**POWER GIRL IS THE EARTH-TWO COUNTERPART TO SUPERGIRL.** Hailing from this alternate dimension, Power Girl is genetically identical to the main continuity Earth-One version of Kara Zor-El and has all the same powers as Supergirl. However, Power Girl's personality is a stark contrast to Supergirl's. Where Supergirl is naive and reserved, Power Girl is brash, aggressive, and mature. She unapologetically wears an outfit that displays her bosom through a strategically placed "cleavage window." When questioned about her costume in *Justice League Europe* #37 (1987), she replied that it "shows what I am: female, healthy. If men want to degrade themselves by staring, that's their problem, I'm not going to apologize for it."

As a fan favorite, Power Girl has had many standout moments in her publication history that speak to readers on a personal level. According to writer Lilah Sturges, "I got a lot of positive responses to *Power Girl* #26 (2011), the story entitled 'Girl Power.' In it, Power Girl gives a speech about female empowerment at a Power Girl convention. There's a double-page spread filled with people cosplaying Power Girl, including at least one trans woman. It was pretty straightforward stuff, nothing revolutionary. But since I was still a closeted transgender woman at the time, I was the only person that knew I wasn't a dude and so I was taking a risk writing it."

Power Girl continues to inspire with her bold persona, incredible power, uninhibited attitude—and she is not going to apologize for it.

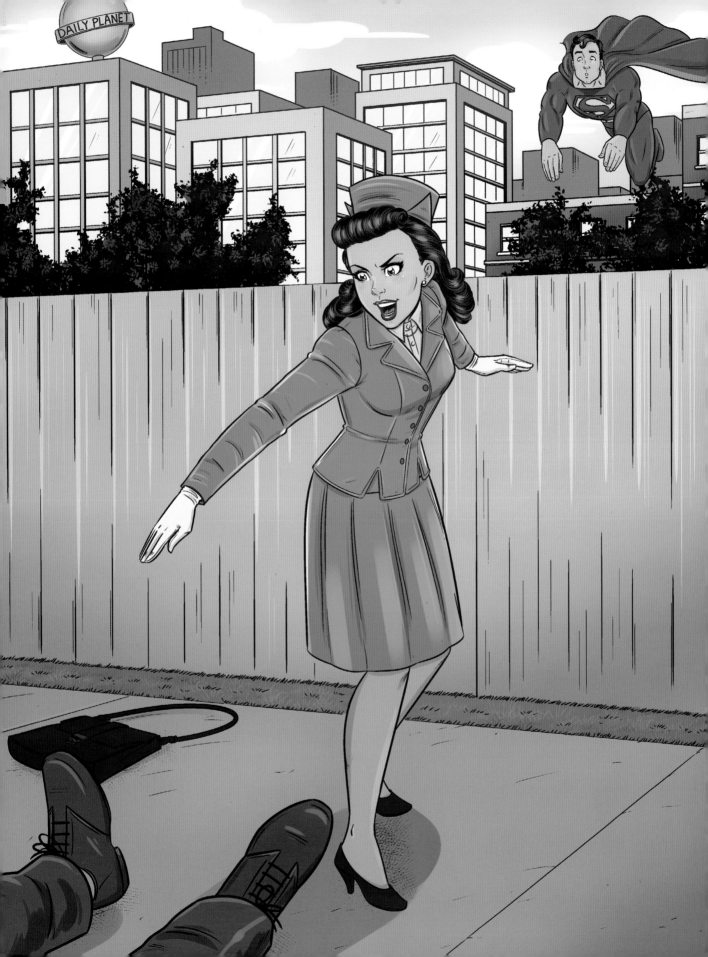

# LOIS LANE

"THE FIRST TIME I SAW LOIS LANE WAS ON SCREEN, AND I FELT THIS
INSTANT RECOGNITION BECAUSE SHE REMINDED ME OF MY MOTHER. IT
WAS THE FIRST TIME I'D SEEN A FEMALE CHARACTER PORTRAYED IN
THE WORKPLACE BEING GREAT AT HER JOB, LIKE MY TEACHER-THEN-
PRINCIPAL MOM WAS. THE THING I ALWAYS CARRY WITH ME IS THE
KNOWLEDGE THAT LOIS IS A HERO EVERY BIT AS MUCH AS SUPERMAN.
SHE'S SMART, BRAVE, AMBITIOUS, FIERCELY COMMITTED TO JUSTICE
AND, UNDERNEATH, VULNERABLE. SHE DOESN'T HAVE SUPERPOWERS,
BUT SHE'S UNINTIMIDATED BY SUPERMAN OR ANYONE ELSE. FOR
EIGHTY YEARS, LOIS HAS BEEN SHOWING US ALL HOW AS GIRLS, AS
WOMEN, AS PEOPLE, WE CAN STAND UP TO—AND FOR—ANYONE."

—**Gwenda Bond**, author, the *Lois Lane* young adult novel trilogy (2016–2017)

**DEBUTING IN** *Action Comics* #1 (1938), Lois Lane has been a part of the
DC Universe since the beginning. In her long history, Lois has undergone
several major character shifts, fluctuating with the times as society's view
of strong women and women in the workplace changed.

During the World War II era, Lois Lane reflected the "Rosie the
Riveter" mentality, stepping up as the fearless reporter, champion of
the working woman, and an inspiration to female workers who recently
entered the workforce while the men enlisted in the war. She balanced
her perpetual portrayals as the damsel in distress with her excellence
in the workplace.

With the onset of the Comics Code Authority (regulations enacted
in 1954 that censored the content of comic books) in the postwar era,

Lois was downgraded to a mere love interest, her signature verve traded for more domestic duties. Still, she was popular enough to headline her own series, aptly but diminutively titled *Superman's Girl Friend, Lois Lane*, which at its peak was the third-bestselling comic in the United States. With stories often revolving around marriage-hungry Lois's desperate ploys to become Superman's wife, Lois became more of a lovesick maiden than a feminist role model. "That was during the day when Lois wasn't a proper reporter," recalled Louise Simonson (writer of *Superman: The Man of Steel*), speaking of the Lois stories she read as a child. "It always aggravated me that she wasn't living up to the potential that I saw in her. As a child, I found that very annoying. I wanted her to get out there and kick some butt."

Luckily for Lois fans, as we progressed into the civil rights and women's liberation eras, and with the addition of editor Dorothy Woolfolk to *Superman's Girl Friend* in 1972, Lois returned to her enterprising investigative reporter roots. Independent, brave, and brazen, she pursued her career above her classic love interest and once again became the embodiment of the empowered working woman.

Through this era, Lois became a fully realized feminist heroine. She proved herself capable in multiple roles, with stints as a qualified volunteer nurse, master of Klurkor (Kryptonian martial arts), and a spy in a criminal organization. Woolfolk ensured that Lois had agency and required less frequent intervention from her caped boyfriend. Lois even briefly broke up with Superman, telling him to leave and "take your super-male ego with you!"

After Woolfolk's departure from DC, the *Superman's Girl Friend, Lois Lane* book was no longer printed and Lois's stories were merged into the

*Superman Family* title. Except for special issues or limited series, Lois's future adventures would be seen primarily in titles headlined by Superman.

Despite the changes behind the scenes, Lois's feminist, working-woman perspective has remained a major part of her character. From fierce-yet-funny Margot Kidder in the *Superman* movies to tenacious Teri Hatcher in the television series *Lois and Clark* to unflinching Amy Adams in *Man of Steel* (2013) to plucky teen blogger in *DC Super Hero Girls*, Lois is the consummate ace reporter. She's curious, stubborn, and willing to fearlessly follow a story anywhere it takes her. She doesn't take no for an answer and pokes her nose where it doesn't belong, always searching for the truth, even if that leads her into trouble.

In her most powerful portrayals, Lois Lane's strength comes from her intellect, intrepidness, and investigative skills, which have inspired countless budding journalists to enter the field. "She had a really cool job," recalls Corrina Lawson, journalist and founding editor of GeekMom.com. "It was the first job I saw a woman on television have that I personally wanted to do. I wanted her job."

Lois doesn't need to don a cape and punch bad guys to change the world. She tackles problems from a different angle than her super-powered beau, but she's just as effective and impactful. Unlike the vigilante heroes she often covers in her articles, Lois works within the system, using journalism to change the hearts and minds of the people and put the bad guys behind bars.

"Growing up, we really loved and admired Lois Lane," recalled Julie Benson and Shawna Benson, writers of *Batgirl and the Birds of Prey* and *Green Arrow*. "Lois continues to be a driven, ambitious, and fearless career woman who happens to be in love with Superman. While most of the world idolizes Superman, he respects and idolizes Lois. He uses her as a role model to become a better reporter and human, which, for a gal with no super-abilities, is a spectacular feat."

Integral to Superman's success, Lois shines as his equal partner. She might need him to get her out of a super-villain's trap, but he also needs her. Lois can simultaneously be a great journalist, a great hero, and a great wife.

The human reflection of Superman's ideals, Lois is an imitable example of heroic values in a real-world setting. She shows us that there are many different ways to make the world a better place. According to the Benson sisters, "'Truth, Justice, and the American Way' might be Superman's credo, but we're pretty sure Lois is the one who inspired it."

# SILVER BANSHEE

"I THOUGHT I COULD RUN FROM IT. I WAS WRONG. NOW AND FOREVER,
I AM . . . SILVER BANSHEE!" —**Silver Banshee**, *Supergirl* #8 (2012)

IN HER ORIGINAL INCARNATION, Siobhan McDougal was a woman oppressed by the patriarchy when she was denied her birthright of being clan leader on the basis of her gender. After the death of their leader, the clan is meant to be ruled by his firstborn, Siobhan. But Siobhan's wicked uncle leads a coup, stealing the power that should be hers. Determined to keep her clan from her uncle's rule, she performs a demonic ritual. The ritual transforms her into the wicked Silver Banshee whose deadly song kills anyone within earshot.

Functioning primarily as an antagonist to Superman, Silver Banshee is driven by vengeance as she rages through Metropolis. She redeems herself, however, going from Super-Villain to Super Hero when she is freed from the demon's control.

The *New 52* rebooted the character as Siobhan Smythe, an immigrant from Dublin who befriends Supergirl. Though Siobhan shares Supergirl's values, she becomes villainous when possessed by Silver Banshee. With powers of superhuman speed and strength, musical persuasion, and sound manipulation, Silver Banshee holds her own against Supergirl. However, her biggest challenge is controlling herself and remaining true to Siobhan Smythe's heroic inclinations.

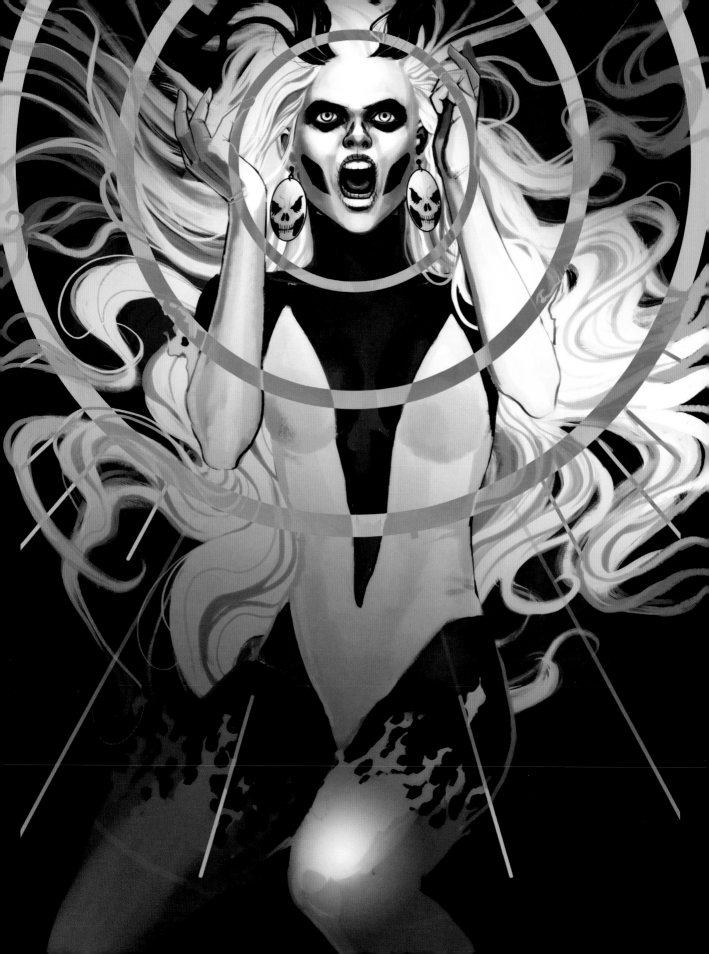

# KILLER FROST

"PEOPLE LIVE LONGER IF THEY LEAVE ME ALONE. TRUST ME."

—**Killer Frost**, *Justice League of America: Killer Frost Rebirth* #1 (2017)

**KILLER FROST WASN'T ALWAYS A COLD-HEARTED WOMAN.** A skilled and thoughtful scientist, Dr. Caitlin Snow happily joined the Scientific and Technological Advanced Research Laboratories (S.T.A.R. Labs) research team in the Arctic Circle, never imagining that this job would forever change her life. In the lab, a subzero accident transforms Dr. Snow into an icy-powered metahuman, and the former good doctor is thrust into a life suited for a super-villain. "I draw her with very inexpressive eyes most of the time, to match her soul," said Mirka Andolfo, artist on *Justice League of America: Killer Frost Rebirth* #1 (2017). "But at important points, she changes that expression, showing some different emotions. I love working on 'badass' characters. And Killer Frost is such a strong character!"

With the ability to absorb heat and project it as cold waves, she can freeze nearly anything, create blizzards, and generate ice forms, including projectiles. However, her powers are a curse. Killer Frost is a heat vampire who needs to feed off human warmth. To survive, she must take the heat of others, which often results in taking their lives. Though in her human form she had no apparent villainous leanings, the circumstances of her survival force Killer Frost to join the bad side.

In the Rebirth continuity, Amanda Waller approaches an imprisoned Killer Frost with the opportunity to join the Suicide Squad, an elite crime-fighting force made up of criminals. Waller tempts Killer Frost with the prospect of helping cure her condition and Killer Frost agrees to join the team. After her work with the Suicide Squad and with her need to feed off human warmth quelled, Killer Frost redeems herself and joins the Justice League of America.

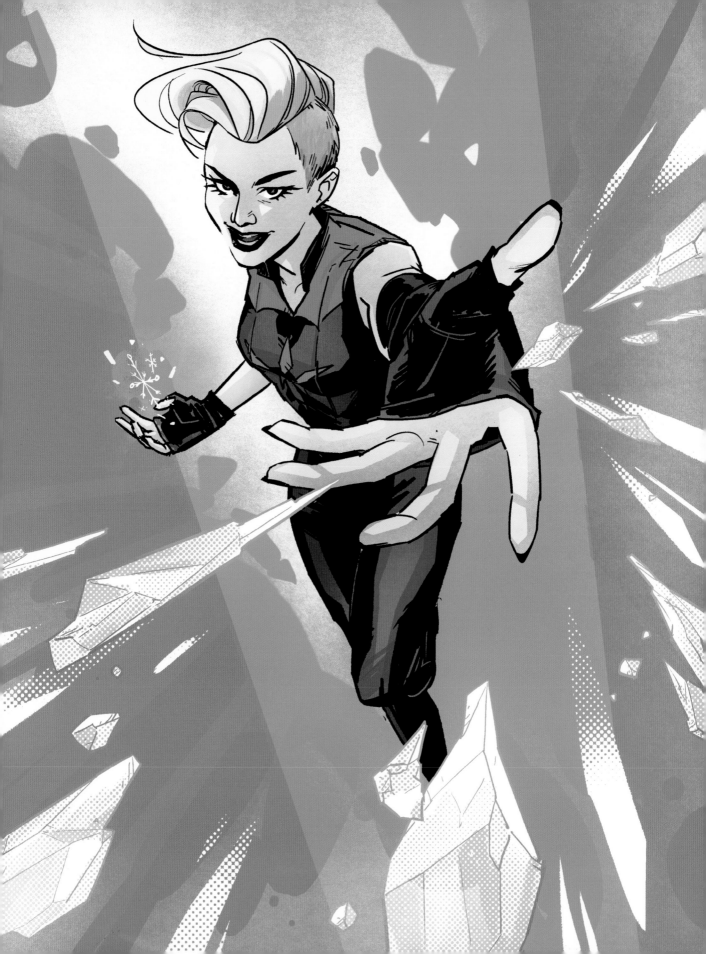

GOTHA

MCITY

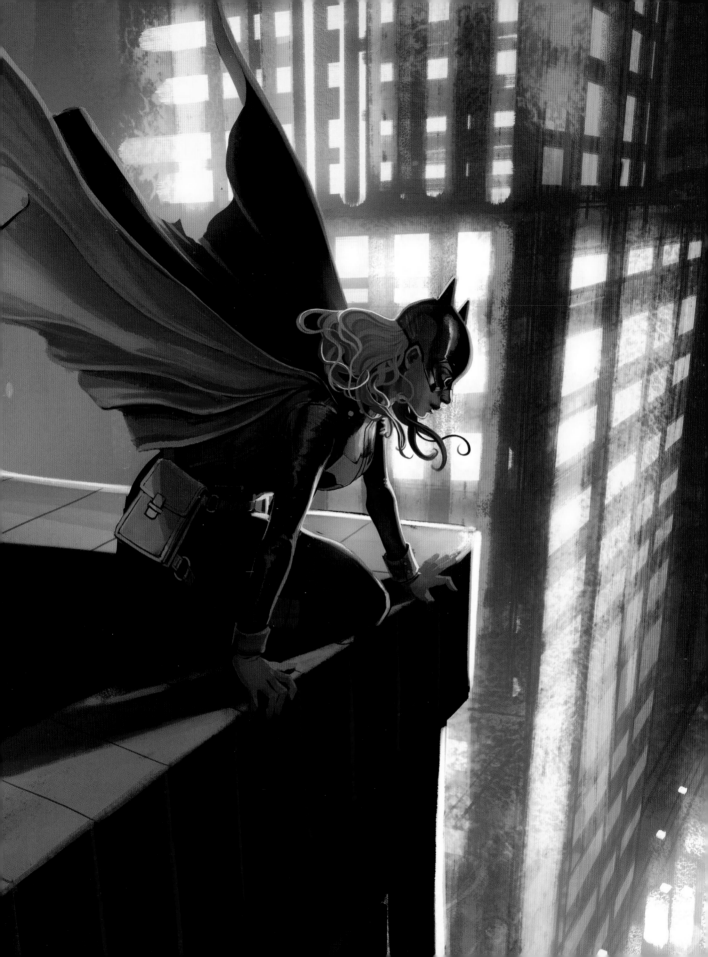

# BATGIRL

"BARBARA GORDON DIDN'T ASK FOR THE TITLE BATGIRL; SHE CLAIMED
IT HERSELF. THAT'S SUCH A POWERFUL MESSAGE BECAUSE REAL
HEROES DON'T WAIT FOR SOMEONE TO ALLOW THEM TO EXCEL.
MORE THAN THAT, WHEN BABS WAS PARALYZED SHE DIDN'T STOP
CRIME-FIGHTING, SHE JUST CHANGED HOW SHE DID IT. THAT KIND OF
DETERMINATION IS WHAT MAKES HER A SUPER HERO."

—**Mairghread Scott**, writer, *Batgirl* (2018–2019)

**THE BARBARA GORDON VERSION** of Batgirl has consistently felt modern throughout her publishing history, ever since first hitting the pages of DC Comics with a *POW!* in 1966. Though the Batgirl character was conceived for the Batman TV series, she made her comic debut before Yvonne Craig's incarnation of the character appeared on the small screen. From the beginning, Batgirl was progressive, transforming herself from the young woman Barbara Gordon to the caped crusader who shunned Batman's interference attempts. In 1972, her *Detective Comics* storyline saw her being elected to United States Congress, which would have put her as one of just thirteen women serving in the House of Representatives that year. With her youthful demeanor and consistently socially progressive storylines, Batgirl is today's hero.

As the daughter of the Gotham City Police Commissioner, James Gordon, it seems natural that Barbara would be drawn to law enforcement, but she initially rebelled against the family business and sought a career as a librarian. Young, agile Barbara doesn't actually conform to the "dowdy librarian" stereotype, but sees herself as the drab academic and longs to break free of that. As she plots her first foray in the Batgirl costume, she

muses, "The whole world thinks I'm just a plain Jane—a colorless female brain! I'll show them a far more imposing girl tonight!"

Barbara's defining characteristic is her immense intellect, which is instrumental in both her everyday career choices as well as superhero work. Though she's undergone a few career changes—congresswoman, forensics science graduate, and founder of Gordon Clean Energy—Barbara never loses her academic pedigree. Her brainpower is the basis of her superpowers.

Like many Bat-Family fans, I first fell in love with Batgirl when I was a kid because she was a normal person, without superpowers, who used the resources available to her to become a hero. She didn't need a lab accident or an insidious government program to make her a hero—she did it on her own. Batgirl was someone whom I could aspire to be like, an attainable goal among an otherwise unreachable pantheon of superheroes.

As a Super Hero, Batgirl is both whip-smart and weapons-savvy. She is skilled in hand-to-hand combat as well as with a variety of weapons and gadgets, many of which she made herself. She is also the DC Universe's top hacker and computer specialist.

One of Batgirl's most compelling traits is that she pursues crime-fighting out of an unselfish desire to help people. She's not a product of a tragedy looking for a way to rectify the past or seeking vengeance for some long-ago wrongdoing. She simply realized that it was the right thing to do.

When becoming Batgirl, Barbara doesn't seek Batman's permission. Though he's the highest figure of vigilantism in town, she's not trying to impress him or become his sidekick. Even when he tries to put an end to her escapades, she sticks to her convictions, insisting that she doesn't need his approval to fight crime and help people.

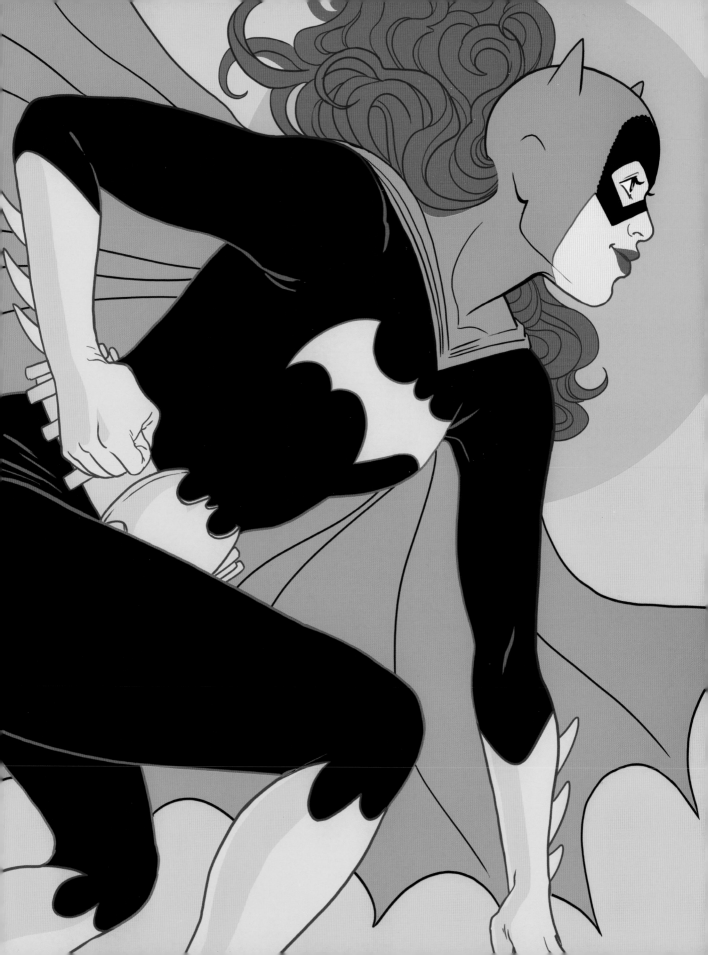

Eventually, Batman comes to accept her and works alongside her. As they pursue their missions together, Batgirl sees Batman as a mentor and brother figure. Their partnership shines when it's built on mutual respect and shared goals. Batgirl is an integral member of the Bat-Family and one of the few recurring female characters in Gotham City who is not a potential love interest of Batman. They're peers, and they don't risk their status as crime-fighting partners by bringing romance into the mix—at least in comic books.

As a member of the Bat-Family and the leader of the Birds of Prey, Batgirl is known for empowering others. She doesn't keep her knowledge to herself, but readily shares it with up-and-coming heroes, training them to fight alongside her. She's never too proud to give her trainees a compliment or too busy to help them try again.

Though Barbara Gordon is the most well-known woman to don the Batgirl uniform, she's not the only one. Betty Kane was the first Bat-Girl, created in 1961, though she soon faded from Batman's life. Cassandra Cain was the first Batgirl to star in her own ongoing comic book series in 1999. As the daughter of Lady Shiva and David Cain, Cassandra is a biracial woman who leaves behind the ways of her assassin parents to become one of the most important heroes in Gotham City. "I've always drawn incredible strength and inspiration from Cassandra Cain, my favorite Batgirl," said Sarah Kuhn, author of *Shadow of the Batgirl*. "She's a powerful fighter, a resilient soul dealing with trauma, and a girl finding her place in the world—I love how those different elements come together to make her

the unique heroine she is. Plus, seeing an Asian American face like my own peering out from the Bat-cowl is awesome."

Additionally, the role of Batgirl has been held by Stephanie Brown, who starred in a twenty-four–issue *Batgirl* series. After her stint as Batgirl, Stephanie would reappear in other books and return to her earlier pseudonym, Spoiler.

Batgirl's books are often socially progressive and feature one of the most diverse casts in comics. Barbara Gordon, in her Oracle persona, was one of the few physically disabled Super Heroes. Gail Simone's *New 52* run on Batgirl introduced Alysia Yeoh, the first transgender character in mainstream comics. Batgirl's roommate, Frankie Charles, is a bisexual black woman with muscular dystrophy. Hope Larson's Rebirth run on Batgirl explored gentrification and shows Barbara as the head of a clean energy company.

With her social justice leanings and heart for heroics, this team player leads the charge both as a hero in her stories and as a symbol of the diverse, inclusive place that comics can be.

# ORACLE

"ORACLE'S BEST POWER WAS ALWAYS HER KNOWLEDGE. I LOVE HER."

—**Gail Simone**, writer of *Birds of Prey* (2006)

**ORACLE IS THE ALTER-EGO** used by Barbara Gordon (aka Batgirl) after she is paralyzed during an encounter with The Joker in 1988's *Batman: The Killing Joke*. The character of Oracle first appeared in *Oracle: Year One: Born of Hope* (1996). Co-created by Kim Yale, this version of Barbara Gordon has lost the ability to use her legs, but she has not lost her heroic spirit. Even more tenacious and determined after being confined to a wheelchair, Oracle uses her intelligence, familiarity with Gotham City's criminal culture, and espionage skills to remain in the game. As one of DC's few physically impaired heroes, Oracle is particularly significant and inspiring. Disability doesn't negate one's heroic potential—a person who is paralyzed can take down villains and save the day.

Oracle develops a vast computer network for her allies, but her mind is the best resource. With her photographic memory and supreme detective skills, Oracle is one of the smartest heroes in Gotham City—even Batman relies on her, and she's integral to many of his successes.

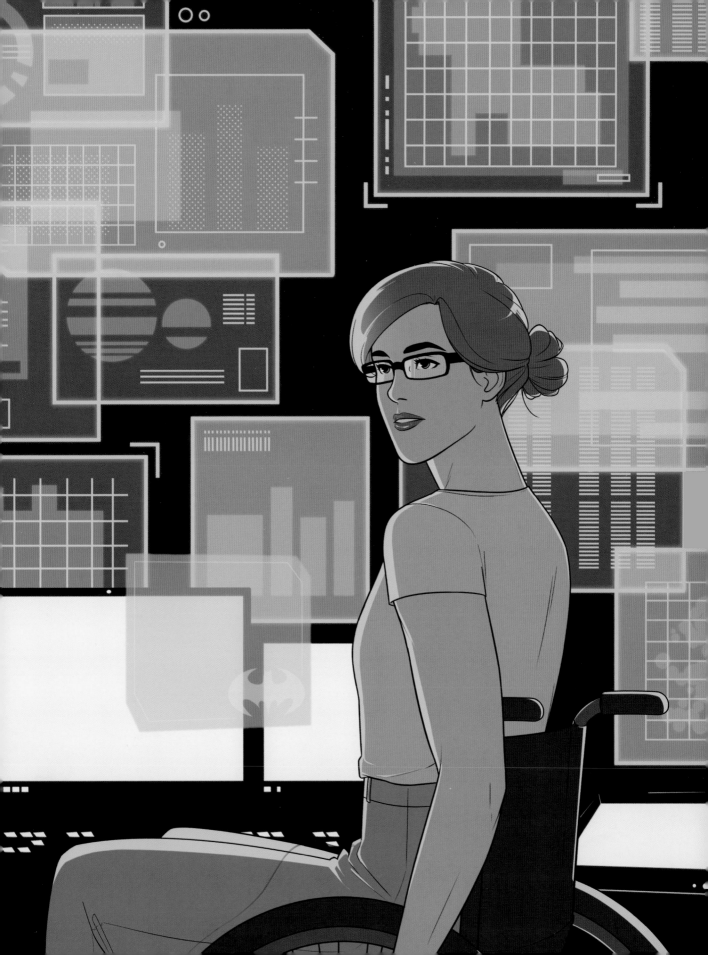

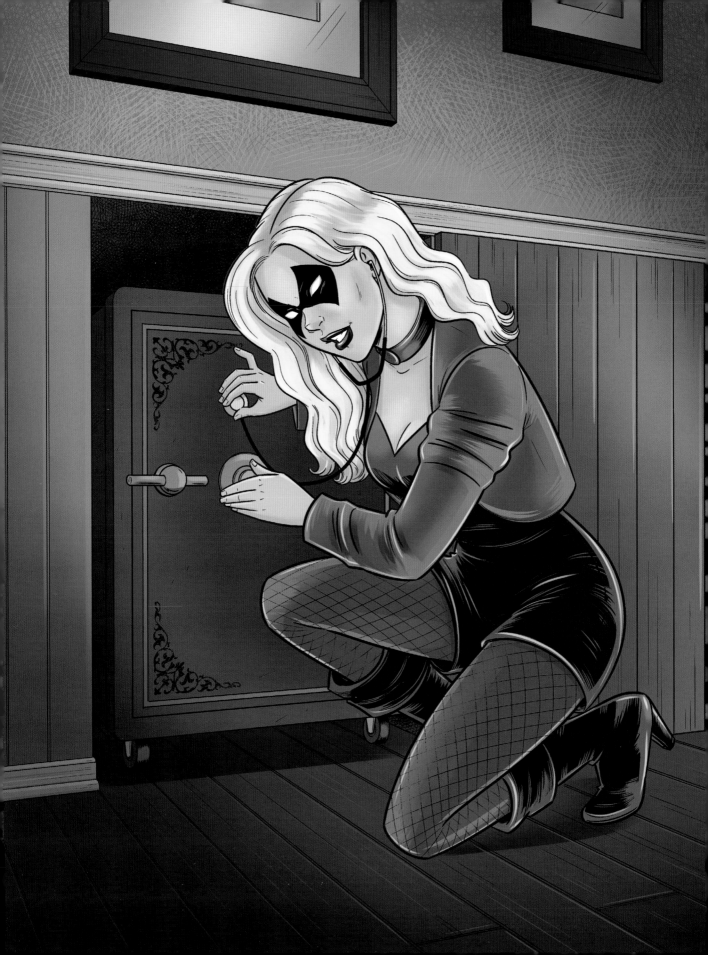

# BLACK CANARY

"DON'T GET ME WRONG. WE'RE NOT FREAKS. WE WEREN'T BORN DIFFERENT. BUT WE BECAME DIFFERENT THE MOMENT WE STEPPED INTO THE HERO ROLE. NOW WE HAVE TO LIVE UP TO IT . . . OR DIE TRYING." —**Black Canary**, *JLA: Year One* (1998)

**BLACK CANARY WAS FIRST SEEN** in a backup "Johnny Thunder" story in a 1947 issue of *Flash Comics.* From seemingly trivial roots, Black Canary has grown into one of the most important female heroes in the DC Universe. In her initial appearances, Black Canary was portrayed as a villain, much in the mold of Catwoman. However, it was revealed that her villainy was part of an undercover ruse, and she was established as the Super Hero she is known as today. With her superior martial arts skills, resilience in the face of adversity, quick wit, and kind heart, this legacy hero has connected with fans for over seventy years.

Like most of her long-standing peers in the comics world, Black Canary has had a number of different origin stories, a myriad of defining plot twists, and two prominent characters who've used the alias. Street-smart Dinah Drake is the first Black Canary to appear in comics. Later, she and her husband, Larry Lance, have a daughter named Dinah Laurel Lance who would take on the mantle of Black Canary.

Black Canary is a fighter, mastering several of the martial arts. Even without meta-enhanced strength or speed, she's able to take on top-level villains and can hold her own against Batman. She's trained to hone her combat abilities, proving that she's dedicated to helping others through her heroism, with or without superpowers.

Though she most often uses her hand-to-hand skills in battle, Black Canary's sole certified superpower is her Canary Cry. The high-intensity ultrasonic vibrations of her scream can destroy anything in its path. Depending on the mythology of the era, the Canary Cry is either the result of a wizard's magic curse or a metahuman experiment. Either way, the ear-shattering Canary Cry is effective in taking down the bad guys. "I was drawn to the character of Black Canary because of her supersonic voice," said Meg Cabot, writer for *Black Canary: Ignite* for DC Zoom, which is the story of a preteen Black Canary. "I love that Black Canary is a girl who not only won't keep quiet, she uses her superhumanly loud voice to fight injustice. She's a perfect role model for all of us."

Black Canary has a striking look, which projects her unwavering confidence. She's overtly sexy with her platinum blonde hair, fishnet stockings, and curve-hugging black bodysuit. Her physical appearance was designed as co-creator Carmine Infantino's "fantasy girl." Beyond being outwardly stunning, Black Canary has a strong personality, a knack for detective work, and a penchant for fighting crime. "She could be sexy when completely in command of a serious ass-kicking," said Gail Simone, writer of many Black Canary stories. Additionally, though Black Canary is compassionate and caring, she's not a people pleaser or doormat. She stands up for herself just as she would stand up for others, and she doesn't allow herself to be objectified.

Black Canary's romantic relationships are often integral to her storylines. Dinah Drake was in love with Larry Lance, a Gotham City Police detective. In a cheeky reversal of the damsel-in-distress trope, Black Canary saves her bumbling beau from the danger in which he constantly

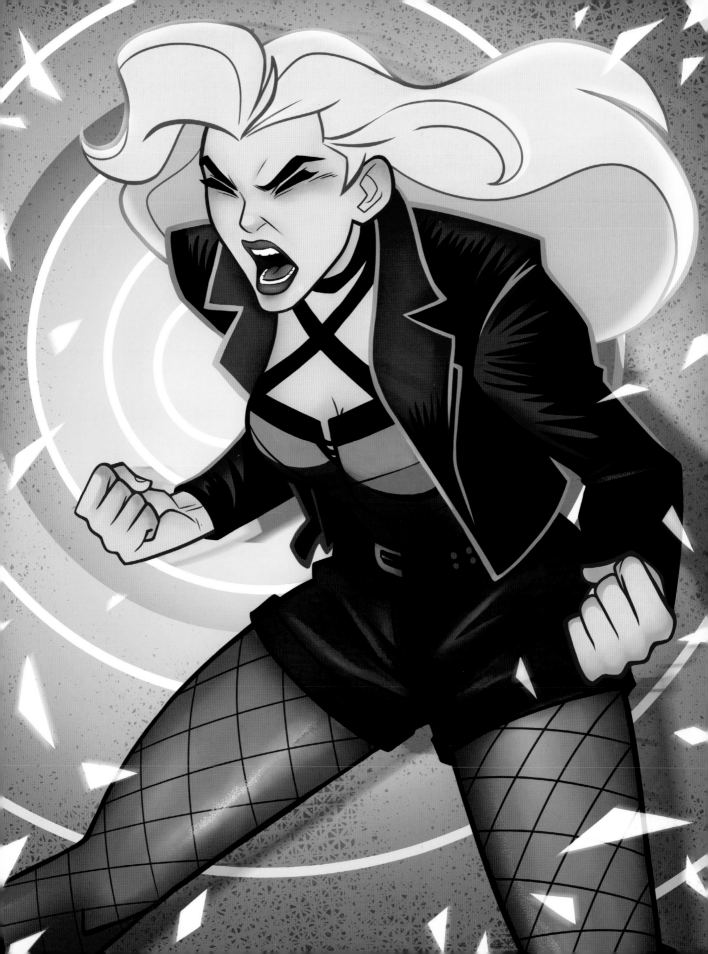

finds himself. Her ability to love and her dedication to relationships creates a soft, human contrast to her hard-punching exterior.

Over time the Dinah Laurel Lance version of the character falls in love with Green Arrow, with whom she partners in fighting crime, and eventually marries in 2007's *Green Arrow and Black Canary Wedding Special*. Like most modern superhero marriages, Black Canary and Green Arrow's wedded bliss would disappear with the *New 52* continuity. The seeds of the Canary/Arrow romance were scattered to the wind and left to sprout in the Rebirth *Green Arrow* series.

While Black Canary was popular enough to be a recurring character throughout the first decades of publishing, she was used sparingly. But the 1980s would see Black Canary's popularity boom as Dinah Laurel Lance took on the alias once used by her mother, Dinah Drake. However, all was not well for the new Black Canary, who would fall victim to a popular trope of this era in which female heroes were horrifically tortured and assaulted in service of a male character's story. The beating she endured stripped her of her Canary Cry and left her on the verge of death, which gave Green Arrow the opportunity to avenge her.

The 1990s would be brighter for Black Canary as she and fellow survivor Oracle would spearhead the all-female crime-fighting team known as the Birds of Prey. As one of the cornerstone characters of the *Birds of*

*Prey* series, Black Canary rocketed to new popularity and became a fan favorite. While surrounded by like-minded female heroes in the Birds of Prey, Black Canary could heal the wounds of her past and become an even greater hero.

Her empathy, loyalty, and regard for relationships makes Black Canary a team player who regularly takes other women under her wing. With supportive friends by her side, Black Canary shines.

Undaunted by the weight of her past tragedies, Black Canary flies to new heroic heights. "Black Canary is every hero's best friend. Everyone from Oracle to Wonder Woman comes to her when they need an ear," said Simone. "And with the bad guys, she's the one who knocks your block off and then picks you up and dusts you off and makes sure you have a ride home."

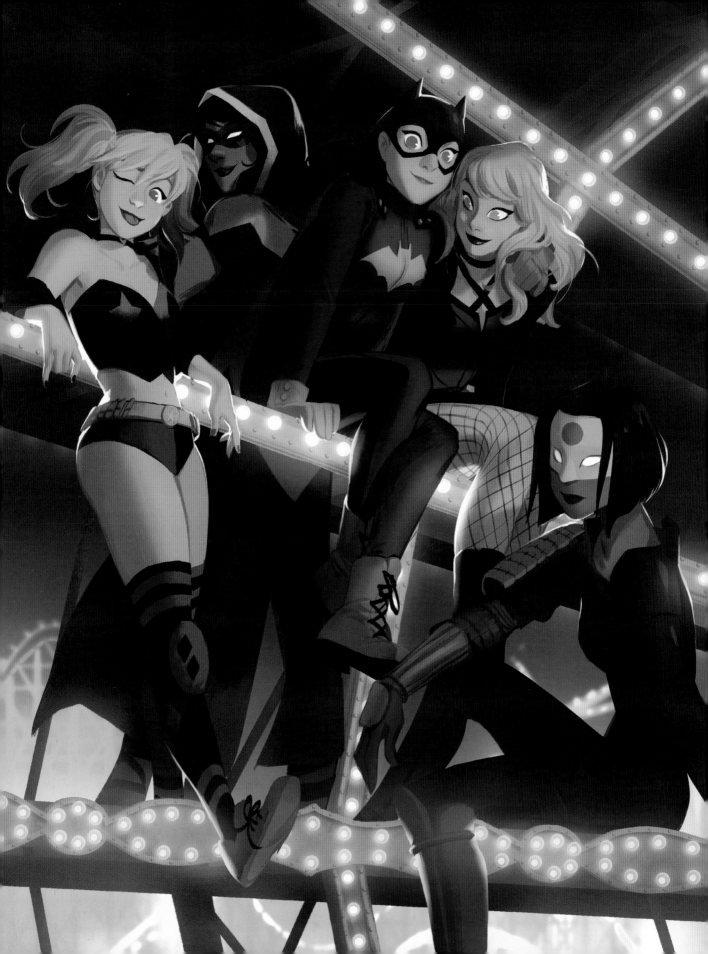

# BIRDS OF PREY

"THE ORIGINAL *BIRDS OF PREY* RUN, FROM THE LATE '90 AND EARLY 2000S, GAVE ME A MULTITUDE OF MODELS FOR FEMALE PERSONALITIES AND RELATIONSHIPS THAT CONTINUE TO LAST—IN BOTH MY PERSONAL AND PROFESSIONAL LIVES. BLACK CANARY, HUNTRESS, ORACLE, AND THE ROTATING MENAGERIE OF WOMEN GUEST STARS SHOWED ME THAT THE INTERPERSONAL MATTERS AS MUCH AS THE MISSION. AND WHEN THE GOAL IS TO BRING GOODNESS TO HUMANITY, THEN THE MISSION MUST FIRST BEGIN WITH THE INDIVIDUAL AND HER TEAM, BE IT COMPRISED OF FRIENDS OR COWORKERS." —**Molly Mahan**, editor, DC/Vertigo

**THE BIRDS OF PREY IS A FEMALE SUPER HERO TEAM** assembled to protect Gotham City from villains and common thugs while Batman and Robin are otherwise occupied. Created in 1996, the team was built around Oracle and Black Canary, with other heroes joining the team as necessary. Throughout their history, the team has included Huntress, Big Barda, Hawkgirl, Vixen, Lady Blackhawk, Power Girl, Katana, Catwoman, and Poison Ivy. When Barbara Gordon left her identity as Oracle to resume being Batgirl, she was still integral to the team. As the roster has changed, so has the Birds of Prey's turf, moving from Gotham City to Metropolis to the city of Platinum Flats.

In the hands of notable female creatives like Gail Simone and the writing team of Julie Benson and Shawna Benson, the Birds of Prey soar not only with their sheer competence, but also with their sisterhood. According to Simone, "It was a book about female friendships that was a huge gateway for new readers who had never found a comic that really hooked them."

Additionally, as the Benson sisters explained, "The team isn't just a crime-fighting unit, they're a family and would take a bullet for each other. Their bond is stronger than just being teammates. They care as much about helping the victims as they do catching the villain. Unlike some teams, the Birds of Prey go out of their way to avoid collateral damage, even if it means letting the bad guy get away. They never let their differences tear them apart because they respect each other enough to work through their conflict and come out stronger on the other side."

# LADY BLACKHAWK

"I LOVE HOW FUN LADY BLACKHAWK WAS. I SORT OF GOT INTO THE HABIT OF MAKING HER BODY LANGUAGE QUITE MASCULINE. SHE HAD THIS ROCKING BODY WITH HILARIOUSLY SHORT SKIRTS, LITTLE ANKLE BOOTS, DIMPLES—I MADE HER SUPER, SUPER CUTE. THEN JUXTAPOSED THAT WITH THIS QUITE BLOKEY, MANLY BODY LANGUAGE." —**Nicola Scott**, artist, *Birds of Prey*

**RECRUITED AS THE FOURTH MEMBER** of the Birds of Prey, Lady Blackhawk brings her expert piloting, combat, and marksmanship skills to the team.

Zinda Blake is a woman out of her time, displaced from her World War II life to the present, where she meets up with Oracle and is recruited into the Birds of Prey. The origin of her pseudonym comes from Zinda's goal to join the Blackhawks, a famous unit of fighter pilots during World War II. She longed to be part of the team, but women were not allowed among their ranks. No matter how well Zinda trained herself, she was denied. But their minds changed when she rescues the Blackhawks from pirates and receives an honorary membership. However, her time fighting Nazis among their ranks would not be long, because during the time-warping events of the "Zero Hour" storyline, she is transported to modern-day Gotham City.

Now, Lady Blackhawk puts her Nazi-trouncing talents to good use as she fights alongside the women of the Birds of Prey to take down contemporary villains. During her tenure on the team, she finds a kindred spirit and close friend in Big Barda.

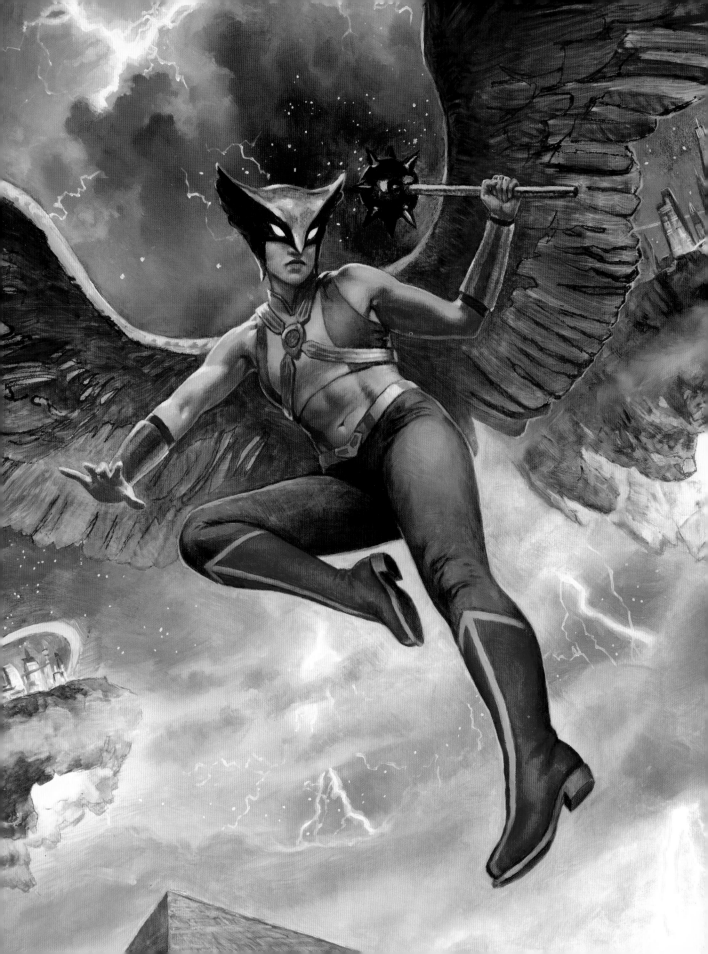

# HAWKGIRL

"I'M NOT SOME DAMSEL IN DISTRESS INCAPABLE OF HOLDING MY OWN AGAINST WHATEVER DANGER COMES MY WAY . . . WHEN I PUT ON THE UNIFORM I'M YOUR EQUAL." —**Hawkgirl**, *Hawkman* #45 (2002)

**HAWKGIRL IS AMONG DC'S EARLIEST HEROES**, first appearing in 1940. Although her feathered wings on her back, bright green tights, and power-granting belt make her consistently recognizable, Hawkgirl stands out as having one of most ever-changing mythologies in the DC Universe.

In many versions of her mythology, the power of Hawkgirl is granted to a human woman via reincarnation and possession of the ancient Hawkgirl spirit. Though wings protrude from her back, her mythology states that her Nth Metal belt is actually the source of her flying powers, and her wings serve merely to aid her flight control.

This legend of Hawkgirl and the source of her powers takes a windy path, starting on the distant planet of Thanagar, landing in ancient Egypt, and emerging in present-day United States. The backstory of the original character Hawkgirl began centuries ago, when the Egyptian princess Chay-ara was murdered with a "Ninth Metal" blade. This weapon doomed Chay-ara to an endless cycle of reincarnation. Whatever human vessel in which Chay-ara was reincarnated became Hawkgirl, and during the initial era, that vessel was Shiera Hall.

After a few decades of Shiera Hall, the twisty tale took a new turn with the similarly named Shayera Hol taking on the Hawkgirl role. "Ninth Metal" was retconned to Nth Metal, a mineral native to the planet Thanagar that gives power to whomever possesses it. This version of the Hawkgirl tale had no Egyptian origins; and rather than gaining powers by being possessed by a spirit, Shayera Hol herself was from Thanagar, which is populated by a hawk-like race of aliens.

The Hawkgirl continuity was relaunched in 1999 in a way that stitched together pieces of the previous versions. This version of Hawkgirl is Kendra Saunders. Kendra became Hawkgirl when she committed suicide as a teenager and was resurrected by the Hawkgirl spirit, which had previously inhabited the body of her great aunt, Shiera Hall.

Though initially reluctant, Kendra embraces her new identity after a little training and the inheritance of Shiera Hall's gear. Kendra is Latinx on her mother's side and one of the first female Latinx heroes in the DC Universe.

Despite the many mythologies of the Hawkgirl character, fans throughout history have consistently been drawn to her. Hawkgirl has been repeatedly reincarnated, but no matter what form she takes, Hawkgirl's powerful spirit endures.

# HUNTRESS

"I KNOW VENGEANCE IS A SIN. SO I PROMISE TO SAY A FEW 'HAIL MARYS' ALONG THE WAY." —**Huntress**, *Batgirl and the Birds of Prey* #1 (2016)

HELENA BERTINELLI WAS BORN ON the wrong side of the law. As the daughter of Gotham City's most prominent crime family, young Helena was raised to pursue a life of crime. However, Helena was a rebel who eschewed that path and found her own way.

After witnessing the tragedy that mob life inflicts, Helena Bertinelli decides to take on the identity of the Huntress. As a costumed crusader, she tries to abolish the kind of criminality that consumed her family. In some versions of her origin story, the Huntress's motivation for going after criminals is purely vengeance for what happened to her family, while other versions skew her motive toward a more noble notion of helping others who suffer the same fate.

Helena can escape the mob, but she cannot fully outrun her past. With her hot temper and uncontrolled rage, the Huntress succumbs to the very behavior she's trying to combat. Clinging to the Catholicism instilled in her in childhood, the Huntress wants to uphold a higher morality but often sinks to unwanted lows in her quest. She falls short of her own standards, which feeds her anger and leads to even more trouble.

Though the Huntress is ostensibly on Batman's side, he sees her darker tendencies and rarely accepts her as a hero. The Huntress gives him a myriad of reasons to distrust her, from disobeying his orders to her enraged outbursts.

The Huntress shines brightest in her work with the Birds of Prey. There, she finds kinship with Black Canary. However, her relationship with Oracle is often strained for the same reasons that it is with Batman. Oracle's tight control of the crime-fighting group tends to irritate the loose-cannon Huntress. Yet, despite the conflicts, the Huntress is an integral member of the Birds of Prey and part of the core cast in the recent *Batgirl and the Birds of Prey* series.

This Super Hero prefers a variety of unusual and exotic weapons including her signature crossbow, which shoots high-powered and tricked-out bolts. Trained in Sicily, the Huntress has an old-world flair to her fighting style and weapons of choice—which serves as another point of opposition to Oracle's high-tech inclinations.

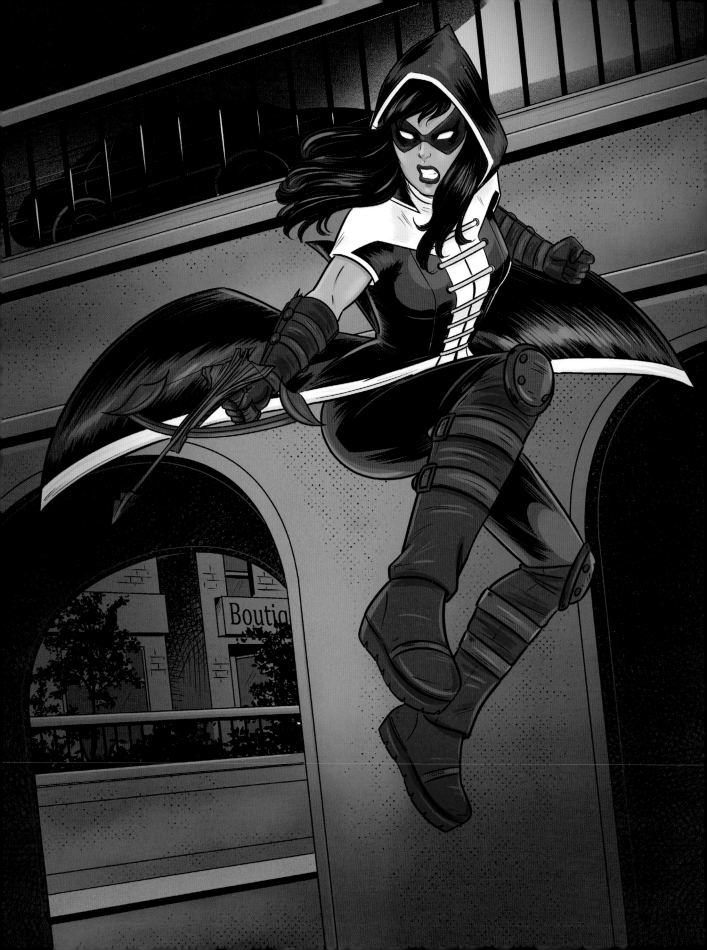

# THUNDER AND LIGHTNING

"WHAT MAKES THUNDER AND LIGHTNING SO SPECIAL TO ME IN PARTICULAR IS THAT THE TWO CHARACTERS GIVE US A WHOLESOME SLICE OF BLACK AMERICANA, AS WELL AS A KIND AND TRUTHFUL REPRESENTATION OF AFRICAN AMERICAN GIRLS LARGELY MISSING FROM SCIENCE FICTION AND FANTASY. IT IS A DELIGHT TO SEE THE TWO GO ON GRAND ADVENTURES, BUT IT IS ALSO EQUALLY DELIGHTFUL TO SEE THE EVENTS OF ONE'S YOUTH MIRRORED IN THEIR QUIETER ACTIVITIES. THOSE HAIR-BRAIDING SESSIONS AND ROLLER-RINK EXCURSIONS ARE IMPORTANT—AS IMPORTANT AS A YOUNG CLARK KENT RACING IN FROM THE CORNFIELD TO SIT DOWN TO DINNER WITH HIS MA AND PA." —**Cheryl Lynn Eaton**, writer, *Batman: Secret Files* #1 (2018)

**ANISSA AND JENNIFER PIERCE** followed in the footsteps of their metahuman father, Black Lightning, to become the Super Heroes Thunder and Lightning. They may be the daughters of a Super Hero, but neither needs nepotism to excel at heroics. With divorced parents, burgeoning superpowers, and facing institutionalized racism, Thunder and Lightning have become some of the most honest and provocative characters in comics.

Though Black Lightning wanted to keep his daughters from the dangers that come with a life of fighting crime, Anissa couldn't resist the call. As she says in *Outsiders* #1 (2003), "I love my dad. I always wanted this. He just . . . I think the last thing he wanted was to raise a superhero." Despite her father's misgivings, with her genetically based thunderous stomping abilities she took on the superhero identity of Thunder and became a crime-fighter. Thunder holds the distinction of being DC Comic's first LGBTQ+ female superhero of color. "We get to see a character integrate and balance multiple identities," said writer Cheryl Lynn Eaton. "It breaks us out of the confining behavior of determining a character's status by one particular label and forces us to examine the entire tapestry of what makes them *them*. And the threads that form Thunder's life lead us to make one very clear blanket statement—Anissa Pierce is a hero."

Like her older sister, Lightning would go into the "family business" as a Super Hero. Though as a teen her extreme powers initially made her feel freakish, she learned to control them and embrace her metagenes. As a member of the Justice Society of America, young Lightning holds her own next to more experienced heroes. With the addition of flight to her electric-based power arsenal, Lightning soars beyond her father's shadow.

# BATWOMAN

---

"MANY OF THE BEST THINGS ABOUT BATWOMAN ARE ALSO THE WORST THINGS ABOUT BATWOMAN. SHE IS A CHARACTER WHO IS SPLENDID AT THE EXPLORATION OF UNCOMFORTABLE MORAL FAILURES. HER RELENTLESSNESS MAKES HER FEARSOME, BUT CAN ALSO BE SELF-DESTRUCTIVE. HER WIT MAKES HER FEEL HUMAN, BUT MASKS HER STRUGGLES WITH SINCERE CONNECTION TO OTHERS. HER CONVICTION POWERS HER, BUT CAN BLIND HER."

—**Marguerite Bennett**, writer, *Batwoman* and *DC Bombshells*

---

**OUT OF A SENSE OF DUTY**, former soldier Katherine "Kate" Kane puts on the cape and cowl and assumes the identity of Batwoman. She's an ex-military Jewish lesbian, but she transcends these labels to become a fully formed, complex, and non-stereotypical hero. "I am inspired by her quest—dauntless, unrelenting, terrible, but not inhumane—in pursuit of justice for a world she knows can never be just," said Bennett. "Alien gods can move stars and tumble mountains into the sea—she has only her will, her time, her life to offer."

A character named "Batwoman" first appeared in comics in *Detective Comics* #233 (1956), but eventually receded out of Batman stories. In 2006, Batwoman was relaunched as a modern character in the series *52*. This contemporary version of the character is DC's first major lesbian Super Hero, who would continue to make history as she headlined *Detective Comics* and eventually her own self-titled monthly series. Cat Staggs, artist on *Wonder Woman '77* (2016), recalled that the relaunch was "both visually stunning and opened the door of representation for so many. Having the chance to read about a mainstream lesbian superhero was something I'll never forget."

Unlike other characters, whose creators were coy about their queerness, Batwoman was relaunched specifically and publicly as a lesbian. Similar to any straight superhero, Kate Kane's sexuality was obvious and her romantic relationships were portrayed candidly in her storylines.

Ironically, the first Batwoman character was introduced to the Bat-Family as a potential love interest for Batman. At that time in the mid-1950s, there was much speculation about Batman's sexuality and Batwoman was introduced to counteract these rumors.

The new millennium version of Batwoman was far more successful. "I was a senior in high school when Batwoman's solo series was announced," said Bennett. "I went into the bathroom and cried. To see a queer character, a queer hero, who wasn't a PR stunt, wasn't a paragon of one-dimensional overcompensation—to see a heroine bearing the symbol of the Bat, and all the weight, grandeur, dread, and history that entailed—I can't tell you what that meant. I felt anchored in our world because I felt anchored in her world."

Beyond being a lesbian icon, Batwoman held her own as a Super Hero. With her military background, she didn't need Batman's training or anyone's help to excel at her work. Resourceful, strong, conflicted, and deeply flawed, she proved that you don't have to be perfect to be heroic. Kate self-medicates her depression with alcohol and sometimes uses the adrenaline rush of crime-fighting for the same purpose. She freely admits the gray morality of her vigilante code in *Batwoman* #3 (2017). "I'm not Batman. Batman would never make the choices I make. Batman would

never choose killers for allies." This version of a hero who dealt with and displayed her shortcomings resonated so much with fans that she even replaced Batman as the lead of *Detective Comics* from 2009–2010.

Kate Kane is also proudly Jewish, shown celebrating Hanukkah in the main universe and fighting anti-Semitism and speaking Yiddish in the *DC Bombshells* universe. Her Jewish identity is just as much a part of her as anything else, and is shown as a source of strength that encourages her to be a better hero.

In Kate Kane's backstory, her dream of being a soldier was cut short when she was kicked out of the military as a consequence of the "Don't Ask, Don't Tell" policy. In the wake of her broken heart, she finds herself in the Batwoman guise, but she still carries the pain of her past. "Pain is how the body tells us something is wrong. There is no shame in pain. There is no shame in scars," she says in *Batwoman* #2 (2017).

More than any other piece of her identity, the thing that makes Batwoman so powerful is that she is not ashamed. She is Batwoman and she is proud.

# RENEE MONTOYA

"THEY'VE ALL GOT IT EASY. THE SUPERS AND THE WONDERS
AND THE VILLAINS. ALL OF THEM. THEY DON'T LIVE IN THE
GRAYS. IT'S ALL BLACK AND WHITE FOR THEM."

—**Renee Montoya**, *Batman Chronicles* #14 (1998)

**RENEE MONTOYA BEGAN HER COMICS CAREER** as a detective with the
Gotham City Police Department, and when the department's corrup-
tion was too much for her to tolerate, she evolved into the costumed
hero known as the Question. Working as a vigilante in Gotham City, the
Question's strong sense of justice and superior detective skills help make
her city safer. In various stories, Renee has been in a romantic relationship
with Kate Kane, making her the first LGBTQ+ Latinx female Super Hero
published by DC.

"I have always wanted to help people in some way, shape, or form, and
what I realized is that part of what was so important about Renee was that
she helped me by making me feel seen. Like I existed in the wider con-
text of things," said *Batman Beyond* writer Vita Ayala. "'Representation
Matters' isn't just a saying—it is a *truth*. Here's Renee, the first Latina
lesbian character I ever saw that wasn't played as a joke or as an object in
someone else's story. She was complex, intelligent, strong, beautiful, and
wicked clever. I have been writing since I learned how to read, and Renee
helped me realize that I could do *that*. I could create and write characters
and stories that would also help people be seen. And maybe also help
engender empathy towards people like me—brown, queer, designated
female at birth, or any combination."

# KATANA

"KATANA'S STRONG SENSE OF JUSTICE, FAMILY, AND LOYALTY ARE THINGS THAT I ADMIRE ABOUT HER—NOT TO MENTION HER EXPERT SWORDSMANSHIP! LIKE SO MANY OF US, KATANA DOUBTS HERSELF. YET, WHEN FACED WITH ADVERSITY, HER TRUE SELF EMERGES—STRONGER AND MORE CONFIDENT THAN SHE COULD EVER IMAGINE. THIS IS WHO KATANA IS, AND WHO WE ARE, TOO." —**Lisa Yee**, author of *Katana at Super Hero High* (2017)

**SINCE THE EARLY 1980S,** Katana has been slicing her way through the streets of Gotham City and beyond. From *The Brave and the Bold* to *Suicide Squad* to her titular series during the *New 52* era, this groundbreaking Japanese hero has been a mainstay of the DC Universe for over three decades.

As a child, Tatsu Yamashiro trained in martial arts, developing a particularly sharp skill with the katana sword that would become her namesake. After her husband and two children were murdered by her brother-in-law, Tatsu took up the sword that slayed her husband, dubbed it Soultaker, and used it to enact her revenge on her brother-in-law and his gang.

But she soon finds that Soultaker is no ordinary katana. Tatsu discovers that this magical sword sheaths the soul of her late husband, giving her the ability to communicate with him through the blade. With knowledge of the sword's special power, she takes on the alias of Katana as she uses Soultaker and her samurai training to combat the evil of the world and protect others from the devastation she suffered.

Though Katana's transition into the Super Hero mythos is rooted in vengeance, she has a shrewd moral compass and a pointed sense of justice. She may partner with some of the most nefarious villains and work outside the law, but she does so in service of the greater good.

Katana has added her unique array of skills to several hero teams including the Outsiders, Suicide Squad, Justice League of America, and Birds of Prey.

Being one of the few Japanese superheroes in mainstream comics, Katana holds special significance for many readers and for the women who have contributed to the character. "There is so little Asian representation in superhero lore that it was a joy and a privilege to write *Katana at Super Hero High*," said Yee.

"When I saw Katana, I thought, 'An Asian hero? This is nice,'" said Janice Chiang, letterer on *Batman*, *JLA*, *Detective Comics*, and many others. Chiang recalled that during her childhood, a post–World War II, anti-Asian sentiment still influenced the popular narrative of comics and, if portrayed at all, Asian characters were usually vilified.

According to Stephanie Sheh, voice of Katana in *DC Super Hero Girls*, "I'm ABC [American-born Chinese] and I grew up liking superhero and sci-fi stories, but I never saw myself represented in any of those characters. I love that this version of Katana was not only strong but artistic. She wasn't a member of the math club or anything you'd expect from a stereotypical Asian character in high school."

As Katana's stories continue, she'll keep shredding stereotypes and forging the trail for greater diversity in superhero comics.

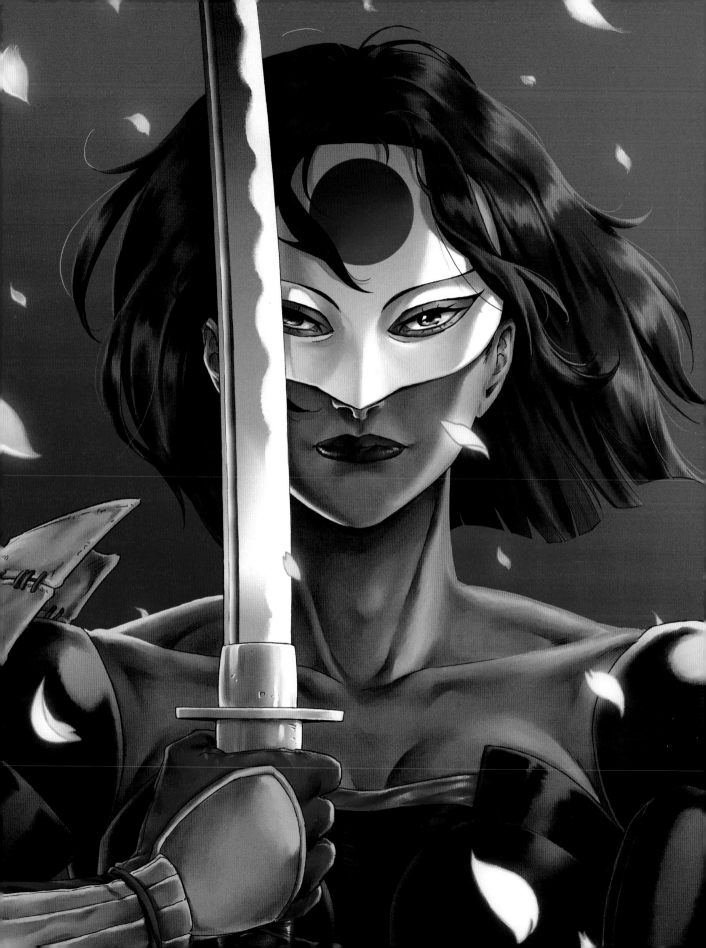

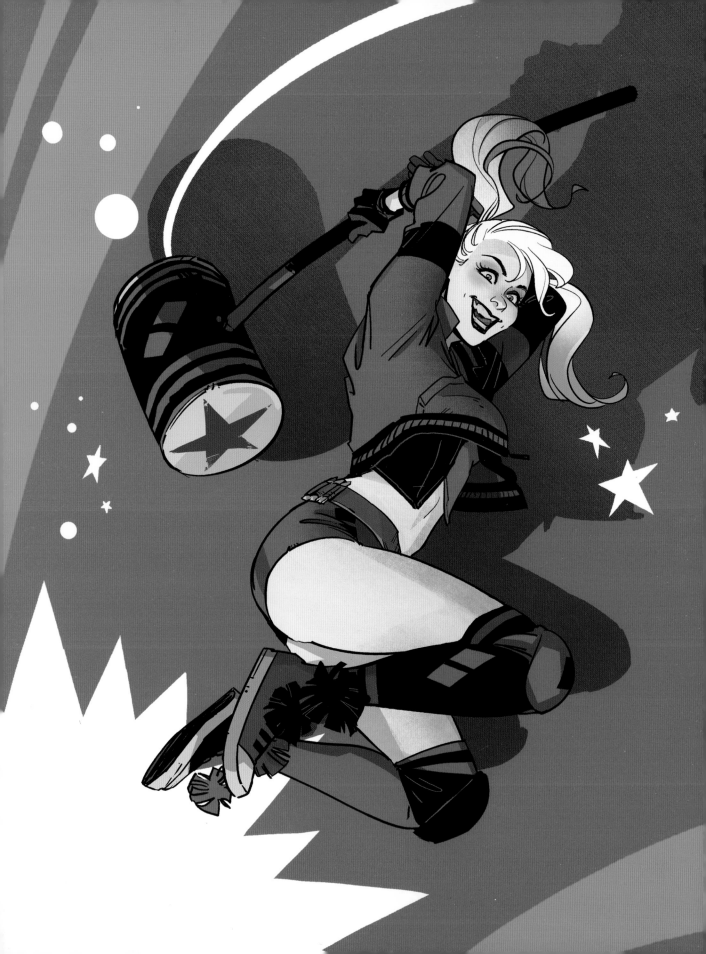

# HARLEY QUINN

"HARLEY QUINN IS UP THERE IN TERMS OF MY FAVORITE SUPERHERO CHARACTERS TO WRITE BECAUSE SHE IS SO PERFECTLY STRANGE AND STRONG AND WILLING TO CAREEN HEADLONG INTO ANY SITUATION. IT'S LIKE RIDING A ROLLER COASTER, JUST KEEPING UP WITH ALL THE THINGS SHE DOES AND WILL HAPPILY DO REGARDLESS OF WHAT THE CONSEQUENCES MIGHT BE." —**Mariko Tamaki**, writer, *Harley Quinn: Breaking Glass* (2019)

**HARLEY QUINN IS ONE OF THE MOST POPULAR** characters in contemporary comics. With her throwback colloquialisms, bombastic personality, jester-inspired styling, and maniacal pursuit of fun, Harley captivates audiences and never lets up—not even for a millisecond. What she lacks in innate superpowers, she makes up for in creativity, agility, and weapons. Crude and crass with a wicked sense of humor, she's unhinged, unbalanced, and unrepentant. "Harley Quinn is what we call a psychopath with a heart of gold," said Amanda Conner, writer and artist of several *Harley Quinn* titles. "She has always been a joyful and lovable person. . . . Granted, she's a very deadly joyful and lovable person."

Wearing her striking black and red outfit, which was modeled after a Harlequin clown, Harley Quinn crashed into the scene in 1993. Created for *Batman: The Animated Series*, Harley's first appearance on the cartoon was meant to be a one-off, but Harley made such a splash that she was soon incorporated as a regular cast member. After her unexpected breakout success on television, her stardom leapt from screen to (as Harley would say) "the funny books," and she was adopted into the mainstream DC Universe.

Her transition from mild-mannered Dr. Harleen Quinzel to criminal is inextricably linked to the Joker. Dr. Harleen Quinzel was one of the top

psychiatrists in Gotham City and she specialized in the criminal mind. Her fascination with criminals led her to Arkham Asylum, where she took on Gotham City's most disturbed minds as her patients. Among her client list was the Joker, the most unstable case in the Asylum. Despite her degree in psychology, Dr. Quinzel didn't diagnose her own downfall as she became obsessed with her new patient.

As a newly converted fervent follower of the Joker, Dr. Quinzel devised a plan to help him break out of Arkham Asylum. After the successful escape, she left her work to become a full-time sidekick and lover of the criminal mastermind. She took on the persona of Harley Quinn, giving freedom to her own insanity that festered just under the surface of Dr. Quinzel. Her slavish devotion to the Super-Villain, and willingness to be a target of his abuse, endeared her to the Joker. Their on-again off-again relationship would be a focal point of many Harley-centric stories, and her villainous identity was rooted in her adoration of the Clown Prince of Crime.

Despite her helpfulness to the Joker, he wasn't into Harley the same way she was into him. She was forced to play second fiddle in his many schemes, never becoming the full-fledged partner in crime she wanted to be. She endured his name calling, tantrum throwing, and penchant for putting her in inescapable dangerous situations in hopes of making him fall deeply and madly in love with her. However, nothing impressed the comedic criminal.

As Harley's story progressed, she realized that she didn't need the Joker to become the reigning queen of crime, so she ditched her bad boy. In the years since, Harley Quinn has come out as bisexual and has been

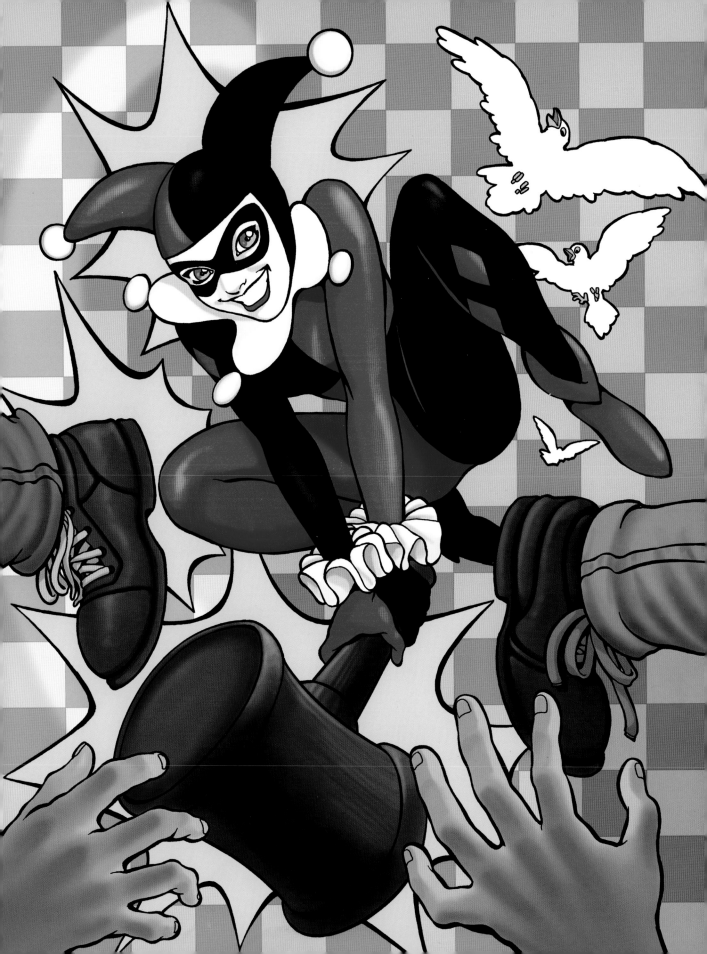

romantically linked to women including Poison Ivy, who helps bring out a softer side of Harley, though Harley still remains true to her rough edges. When Harley is with Ivy, she's out of the shadow cast by the Joker's abuse and proves that she can love and be loved in a healthy way—at least as healthy as Harley wants to be.

Throughout her comics history, Harley has evolved from off-kilter, cold-blooded killer to anti-hero who may even save the day—when she's in the mood for it. Harley acrobatically jaunts along the tightrope between villainy and heroics, dabbling in a little of each as the breeze blows her. In her solo Rebirth continuity comic series, Harley Quinn pursues a solo crime career. "We took the Brooklyn girl out of Gotham and brought her back home to Brooklyn so she could get away from bullying Bat-people and lousy loves . . . and to highlight her quirky attributes, her new life, and what makes her tick," said Amanda Conner. "Then she was able to really blossom into the world's favorite homicidal honey."

Harley may not show much compassion or care for humanity, but she does have a spot in her heart for her menagerie of animals. She can adore a warm and fuzzy animal—like her trained hyenas or pet monkey—without ever being warm and fuzzy herself.

When Harley does fight for good, it's never from a place of heroic idealism. She may do something with heroic consequences because it otherwise serves her egomaniacal agenda. Her mercurial relationship with the law lets her drift through several groups, including the Gotham

City Sirens, Suicide Squad, Secret Six and, eventually, the Birds of Prey. In her eponymous comic, she joins a roller derby team and gleefully leads whoever is foolish enough to follow her. She can be part of a team, but she loves being the star of the show.

In her comic adventures, Harley often ditches the classic black-and-red motley onesie costume from her first appearance in favor of tiny shorts and bustier. As portrayed by Margot Robbie in *Suicide Squad* (2017) and *Birds of Prey* (2020), with multicolored pigtails and cheeky attire, Harley embraces an air of girlish innocence as she bludgeons her enemies with her bat.

With her sense of zany indifference, Harley is matchless among the heroes and villains of the DC Universe. She is distinct from both the sober, moralistic, self-controlled heroes and their vengeful adversaries. Harley stands out from the crowd by being a big, bold ball of unique, relentless fun. "I especially love the crazy approach she has to anything in life," said Mirka Andolfo, artist on *Harley Quinn* #56 (2018). "She lives like the entire world was a sort of playground." Play on, Harley, play on.

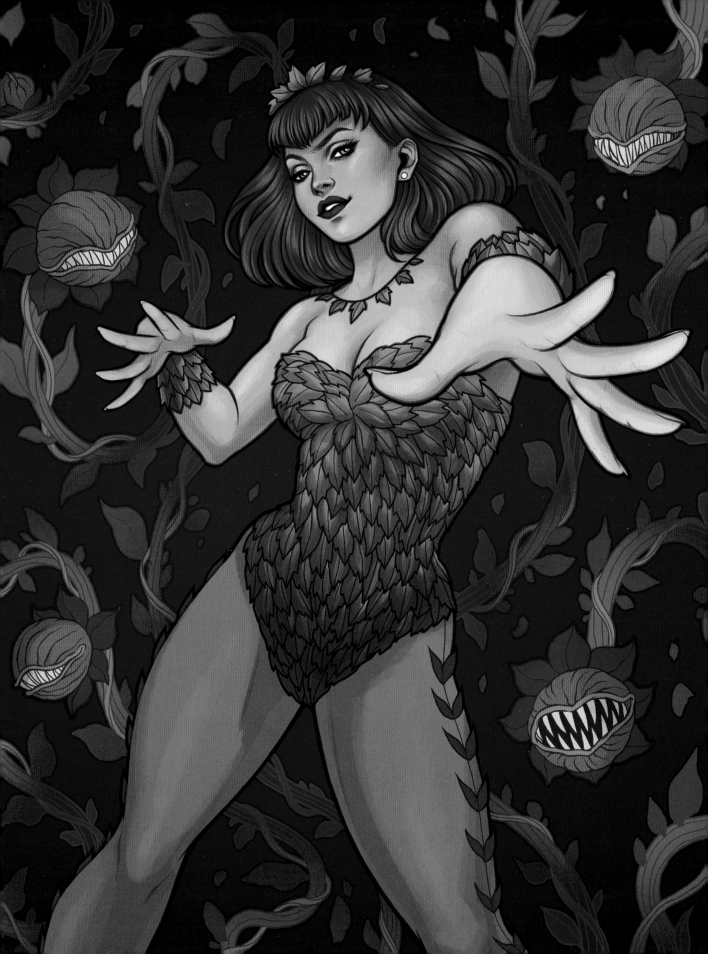

# POISON IVY

"LIFE ENDURES. IT ADJUSTS AND GROWS STRONGER. THE WEEDS YOU TRY TO KILL BECOME SUPER-WEEDS, IMMUNE TO YOUR POISON. AND SO YOU INCREASE YOUR TOXINS AND POISON THE WORLD IN A CYCLE OF MADNESS. I CALL IT FORTH, THE POWER OF THE PLANTS, EVEN FROM THE TERMINATOR SEEDS THAT SHOULD NOT GROW. I AM THE GUARDIAN OF THE GREEN. I AM POISON IVY."

—**Poison Ivy**, *Secret Origins Vol. 3*, #10 (2015)

**POISON IVY HAS BEEN A PROVERBIAL THORN** in Batman's side since she blossomed into the Gotham City scene in 1966's *Batman* #181. Because he is the perpetual foil to her ecoterrorism plots, Poison Ivy sometimes preemptively targets Batman to stave off his potential interference with her bigger plans. With her army of manipulated plants doing her bidding, Poison Ivy is a challenging adversary to any superhero that dares face her.

Genius botanist Pamela Isley emerged from a lab experiment with an array of plant-based powers: the ability to control and manipulate plants, immunity to plant toxins, and a poisonous, pheromone-fueled kiss. Under the pseudonym of Poison Ivy, she uses these superpowers in addition to her organic botany brilliance to protect the world's flora by any means necessary.

In her pre-powered form, Pamela Isley is often portrayed as lacking the confidence she finds as Poison Ivy. She's a downtrodden underdog who finds the seeds of courage inside her as she takes her traumatic

lab accident and turns it into her cause. With her newfound abilities, she blooms into an assertive femme fatale, able to manipulate others as easily as she manipulates plants.

But unlike some of her villainous counterparts, Poison Ivy isn't focused on riches or ruling Gotham City. Amy Chu, writer of *Poison Ivy: Cycle of Life and Death*, describes the character's unique perspective, saying, "Poison Ivy is inspiring because of her intellect and power. She is one of the smartest and most powerful characters in the DC Universe but she's not interested in control like Lex Luthor."

At the root of her character, Poison Ivy is environmentally minded, preferring plants over people. However, her creative contributors have approached this quality through different points of view. Through her history, interpretations of Poison Ivy have swung from classic Super-Villain to modern antihero.

As a Super-Villain, Poison Ivy is portrayed as an ecoterrorist who will stop at nothing as she fights for a greener world. Her goals can be admirable and worthy, but she pursues them in extreme ways, without concern for the human price of her success.

Through a more heroic lens, Poison Ivy shares common ground with her justice-minded peers, gung-ho for the cause she believes in. She sees herself as the heroic vigilante who is willing to sacrifice herself for her

mission. Her morality is skewed in favor of plants, but she is capable of kindness and doing the right thing for the world.

Despite her flora-favoring ways, Poison Ivy is particularly fond of one person: Harley Quinn. Whether portrayed as friends or lovers, Poison Ivy's quiet introspection balances Harley's extreme extroversion. They bond over their outsider status and establish a sisterhood with each other, finding freedom from the dominance and abuse they were accustomed to in prior relationships.

Harley Quinn isn't the only one who loves Poison Ivy—fans of the character are enthusiastic about the green-eyed girl. "Poison Ivy has to have the most diverse and passionate fan base for a character that has gotten not a lot of story time in comics," said Chu. Whether it's her intelligent activism or her brilliantly bad persona that draws them in, Poison Ivy will keep growing and blossoming for her fans.

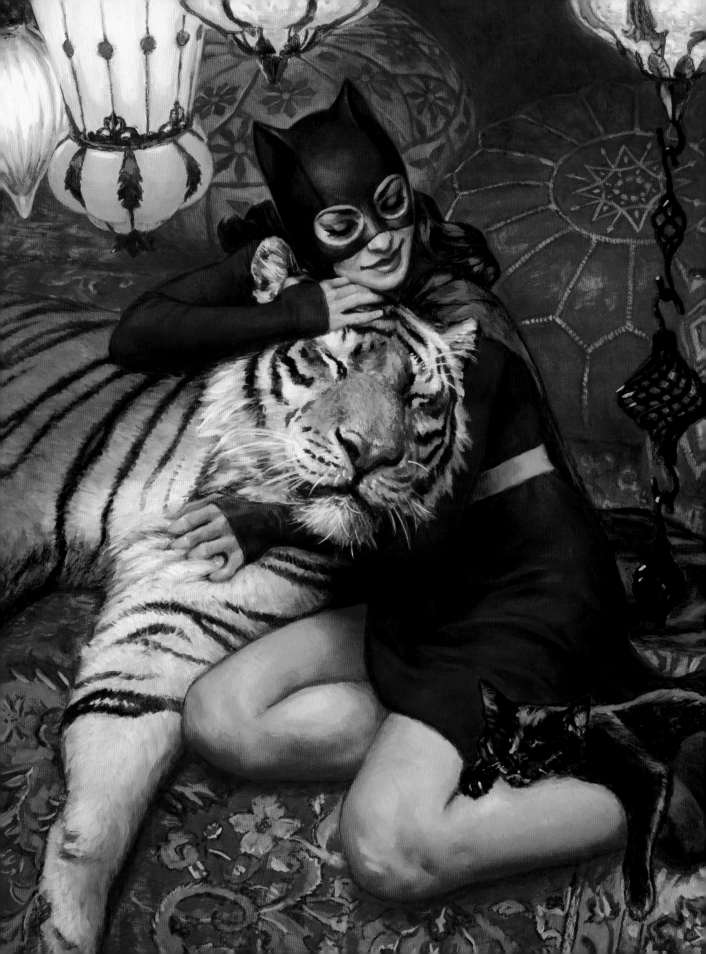

# CATWOMAN

"YOU CAN BE WHOEVER YOU WANT TO BE BENEATH THAT MASK. THAT'S WHY WE STAY HIDDEN, ISN'T IT? SO WE'RE SAFE AND ARMORED. SO WE'RE ACCOUNTABLE TO NO ONE." —**Catwoman,** *Batman: The Dark Knight* #18 (2013)

**SELINA KYLE IS NOT YOUR AVERAGE CAT BURGLAR.** When she dons the Catwoman costume, she's one of the best burglars in Gotham City. Catwoman cartwheels over the line between Super-Villain and anti-hero, and occasionally dips her paw into Super Hero territory. "I've always really appreciated and enjoyed Catwoman for the contradictions in her character, for breaking the rules but upholding them at the same time," said Alison Gill, SVP Manufacturing & Operations at DC. "But most of all living life on her terms and for proving that it's more than OK not to be perfect."

Melissa de la Cruz, writer for *Batman: Gotham High* (2019), which features a teenage Selina, echoed the appreciation of Catwoman's complexity: "I love Catwoman because she's so conflicted and has a vulnerable side along with the kickass, sultry, fighting side," said de la Cruz. "It's almost like she's her own worst enemy."

Catwoman has been in the DC Universe since the start, when the character of "The Cat" debuted in *Batman* #1 in 1940. In issue 2, she evolved into "Cat-Woman," and later into the single-word handle, "Catwoman." No matter what she faced—an extended hiatus, a multitude of ever-changing tragic backstories, or even her actual death—she always bounced back.

Selina Kyle was orphaned at a young age and became a petty thief out of necessity. With a knack for larceny and a nimble body, she honed

her skills and moved from pickpocketing to full-on heists. From the first time she took on the alias of Catwoman, she played by her own rules with a bendable morality. Though greed can be one of her motives, she targets those who can spare it and others who deserve punishment. She often acts as a Robin Hood–type figure, stealing from the rich to give back to Gotham City's poor. Plus, she's always willing to do—or steal—whatever it takes to help a cat rescue charity.

When the character was created, the Batman world was male-dominated with the only regularly appearing recurring female characters being Bruce Wayne's girlfriends. But Catwoman stands apart—she isn't a sidekick or a helpless girlfriend, but a lone, formidable force and proficient foe. From the beginning she breaks through the male-dominated world of super-villainy and proves that she could be just as effective as any man. She doesn't just fight guys—she's taking down the patriarchy.

One of Catwoman's most endearing traits is how she makes everything she does seem easy. She approaches each heist with complete confidence. She's not unjustly arrogant or pompous, but she demonstrates an assurance that she is experienced and competent. In the end, she does it all without an apparent scratch, even when Batman is left battered.

Catwoman believes in herself and doesn't need anyone else's approval. However, that doesn't mean that Catwoman is anti-relationship. "Selina Kyle is ferociously independent; and yet, if she lets you in, she's ferociously loyal," said Lauren Myracle, writer for *Catwoman: Under the Moon* (2019), a YA-skewed take on Catwoman for DC Ink. This loyalty has been portrayed for nearly eight decades in the romance between Catwoman and Batman, which is one of the most famous and enduring relationships in comics.

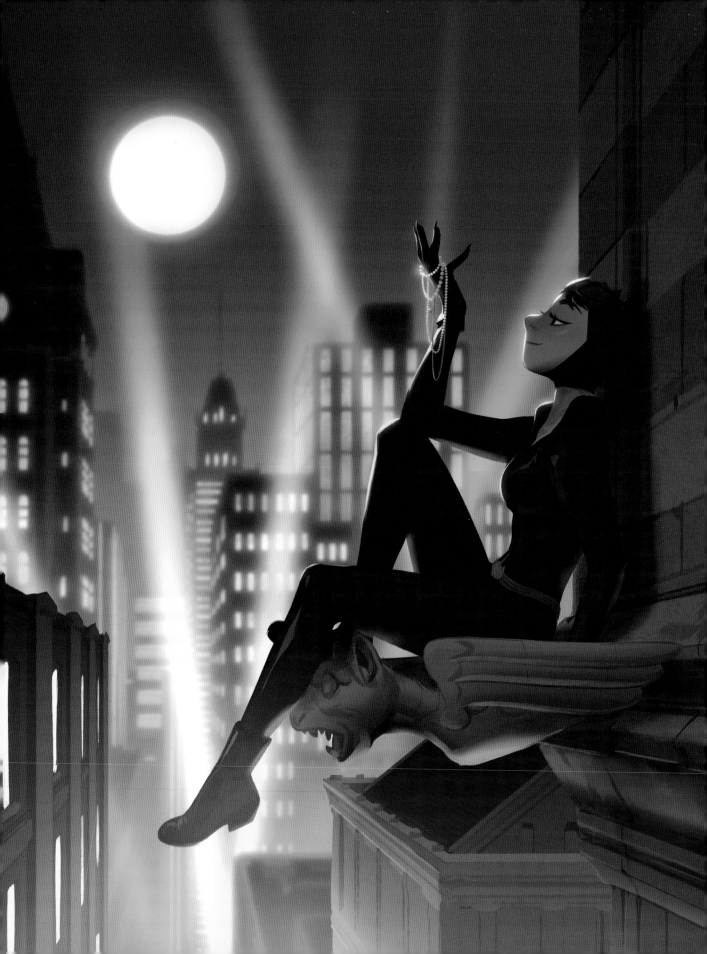

With her quick wit, catlike reflexes, and unpredictability, Selina is one of the few women who can hold Bruce's attention. "She's very much like Batman but the opposite side of the coin," said Joëlle Jones, writer and artist on *Catwoman* (2018). "She's full of contradictions." When it comes to strategy, intelligence, and willpower, Selina is Bruce's equal. Her sense of humor and sass balance his dark, brooding demeanor. As both an orphan and a costumed crusader, she relates to Bruce on a deep level and offers him companionship in his vulnerabilities.

One of the reasons that their romance flourishes is because Catwoman is allowed to be herself first and the love interest second. She exists as a complex character with independence, ambition, and a fully formed life outside of her interactions with Bruce Wayne.

Additionally, because Catwoman is often a criminal and antagonist to Batman, their relationship is firmly in the "opposites attract" category. Though their outward alliances on the hero-versus-villain fight don't match, their deeper values and abilities often align. By nature, their romance must withstand constant conflict, but their love for each other prevails.

Beyond her relationship with Batman, Catwoman is shown to have several close female friends, including fellow antiheroes Poison Ivy and Harley Quinn, as well as civilian pals like Holly Robinson, Alice Tesla, Kitrina Falcone, and Gwen Altamont. She respects other women and happily works with them.

"I imprinted on heroines who did not have to be so aspirational, so good. Instead, I imprinted on Harley Quinn, Poison Ivy, and Catwoman—characters who did not have to be good, but who got to be themselves," said Marguerite Bennett, writer of *DC Bombshells*. She may not be perfect, but Catwoman is always purr-fectly herself.

# CARRIE KELLEY

"IT'S YOU AND ME AGAINST THE WORLD, BOSS."

—**Carrie Kelley**, *The Dark Knight III: The Master Race #4* (2016)

**CARRIE KELLEY MADE HISTORY** as the first full-time female Robin in 1986's *Batman: The Dark Knight Returns*. As a precocious thirteen-year-old, Carrie sets out to prove herself worthy of being Batman's sidekick by donning a makeshift Robin outfit and becoming a small-time vigilante. Persistent and proficient, Carrie wheedles her way into the Bat-Family, impressing Batman with her enthusiastic, stubborn desire to help.

Though not an orphan like other iterations of Robin, the neglect from Carrie's parents permits her crime-fighting escapades to go unnoticed and provides her with the sparse level of parental supervision required by a teenage Super Hero. She finds a father figure in Batman as she joins him in his mission to protect Gotham City.

At thirteen, Carrie is the youngest major female hero in this book. Despite her youth, Carrie isn't naive or incompetent. Carrie proves that little girls can outrun, outperform, and out-punch the male counterparts who wear the red onesie, green boots, and yellow cape.

As she matured, Carrie took on the alias of Catgirl in her later teen years. With additional training from Batman, plus her motorized skates and a batarang-blasting arm cannon, Catgirl remains Batman's second-in-command while being an exceptional crime-fighter in her own right.

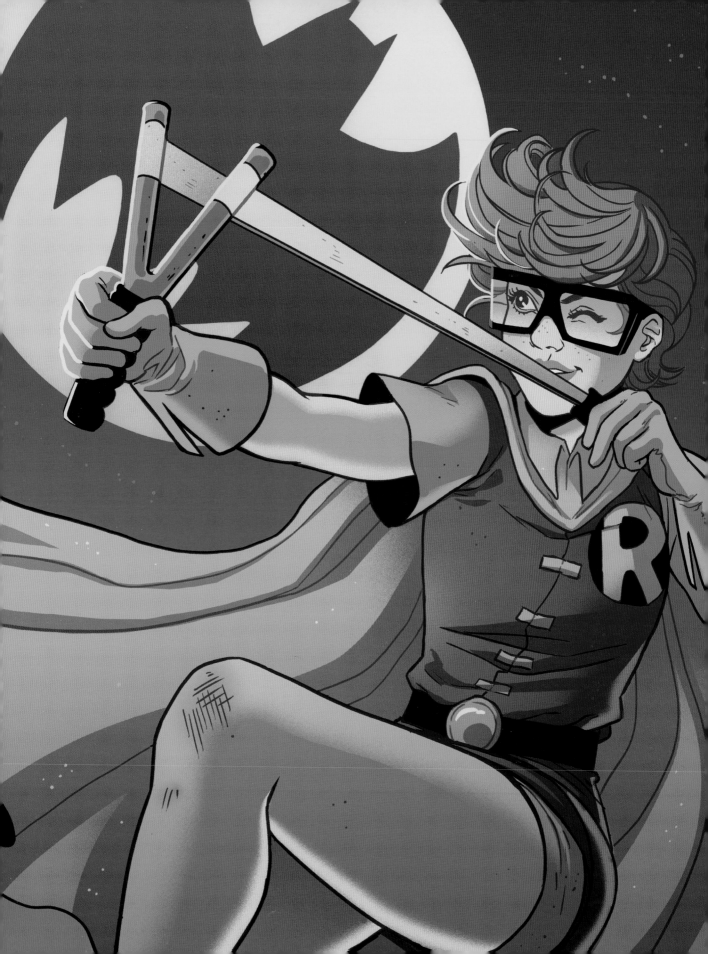

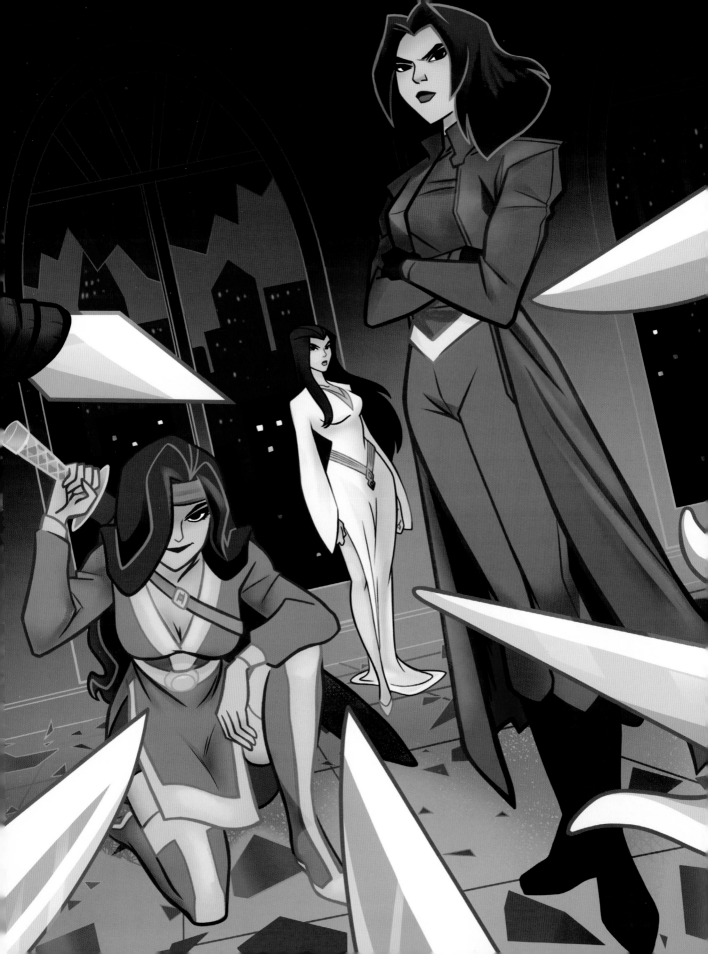

# THE WOMEN OF THE LEAGUE OF SHADOWS

"I'VE DONE MANY EVIL THINGS. I WILL DO MANY MORE EVIL THINGS. BUT THAT IS NOT WHAT I AM. THAT IS NOT WHY I AM HERE. AND SHIVA WILL NEVER YIELD." —**Lady Shiva**, *Batman: Detective Comics #956 (2017)*

**THE LEAGUE OF SHADOWS IS A GROUP OF HIGHLY SKILLED ASSASSINS.** Though they work throughout the world, they are primarily presented as antagonists of Batman. Among the ranks of this deadly criminal organization are some of the wickedest women in the DC Universe, including Talia al Ghūl, Lady Shiva, and Cheshire. In addition to these three most prominent women, the League has included other notables such as Nyssa Raatko and Cassandra Cain.

Talia al Ghūl is the daughter of the League's founder, Rā's al Ghūl. Though she inherits her position of leadership, she is unquestioningly a great fit for the job. With her expert-level martial arts and swordsmanship skills, Talia can take down anyone who dares stand up to her.

Lady Shiva, whose birth name is Sandra Wu-San, is a Chinese woman who has mastered all the martial arts—including the forgotten ones—to become one of the best fighters in the world. Because of her exceptional skills, Batman chooses Lady Shiva as his trainer after his back is broken by Bane.

The League wouldn't be a proper deadly team without a poison specialist, and Cheshire fills that role. Born to a Vietnamese mother, Jade Nguyen learns the art of poisons as part of her radicalization and takes on the identity of Cheshire, who laces her claw-like fingernails with deadly poisons.

# ZATANNA

"NIAHC, KAERB!... EB ELOHW!"

CHAIN BREAK    BE WHOLE

—**Zatanna**, *Zatanna* #12 (2011)

**WITH GENETICALLY BASED MAGIC ABILITIES** of sorcery, transmutation, teleportation, and elemental manipulation, Zatanna Zatara followed in her parents' footsteps and became one of the most powerful magicians in the DC Universe.

As a member of the innately magic-powered race of Homo Magi, Zatanna casts spells by chanting her commands in a fashion where every word is spelled backward. Her voice is both the primary instrument and the conduit of her power. Thus, attempts to thwart her often center on stripping her of her ability to speak, through physical or magical means.

Zatanna's unique way of spell-casting has been a source of inspiration for many of her creators. "I was entranced by the idea that she did her magic by talking backwards and so when I had the opportunity to write her, I wanted to focus on that," said Lilah Sturges, writer of *Zatanna* #12 (2011). "I hit upon the idea of using palindromes but was certain that someone else must have done a Zatanna story with them, and was stunned to discover that nobody ever had. It's maybe the most fun I've ever had writing a single issue of comics."

"The thing that actually resonated most with Zatanna was the conflict that resides between Zatanna's supernatural powers and her imperfect humanity," said Misty Lee, magician and voice actor, whose top-hatted stage persona is strikingly similar to the version of Zatanna written by her husband, Paul Dini. "Trying to find the balance between those two is an ongoing struggle for her, and seeing someone as powerful as Zatanna—who you'd think could just fix things with a quick backwards phrase—continue to make mistakes, fail in relationships, and miss her father really puts things in perspective."

Zatanna is one of the few characters who flows between the main DC Universe and the mature-themed Vertigo books world where she often partners with John Constantine. In the DC Universe, Zatanna has starred in her own titular titles and backup series and is often featured in Batman titles or ensembles such as *Justice League Dark* and in various incarnations of the Justice League. She's versatile, has supernatural staying power, and makes every book she appears in more interesting. Now that's "cigam."

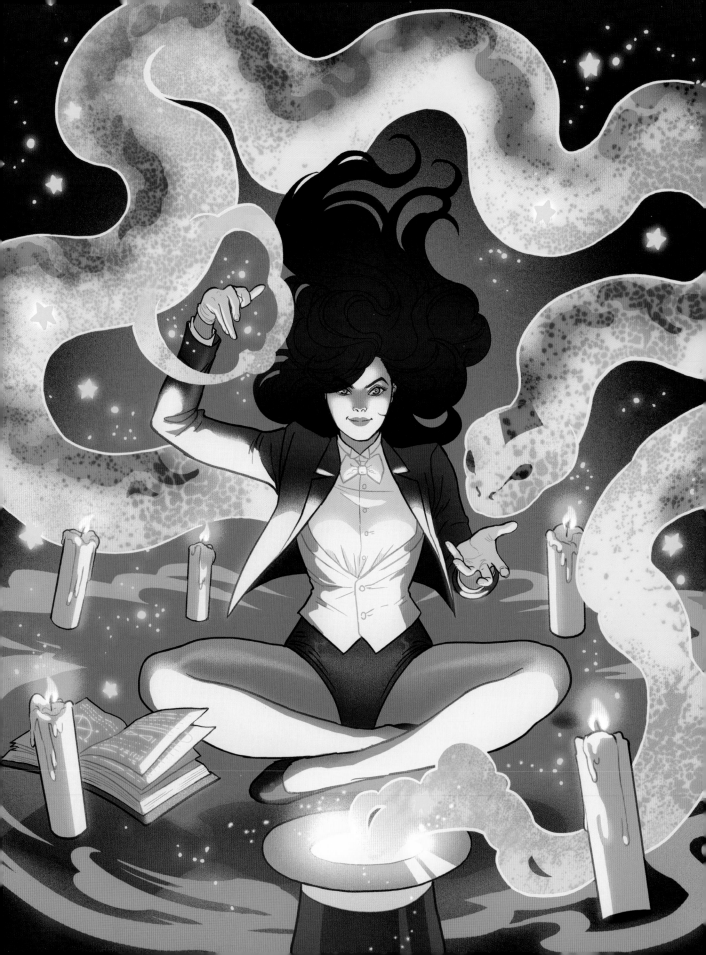

BEY

OND

# AMANDA WALLER

"ONE OF THE THINGS THAT I FIND THE MOST INSPIRING IS [AMANDA WALLER'S] RESOLVE AND HER DRIVE TO GET THE WORK DONE, NO MATTER WHAT IT TAKES. COMBINED WITH HER CUNNING APPROACH TO PROBLEMS, YOU HAVE A PERFECT RECIPE FOR SOLVING PROBLEMS BOTH IN STORY AND IN REAL LIFE. THAT IS SOMETHING THAT I NEED IN MY LIFE, AND BEING ABLE TO WRITE AMANDA AND CHANNEL THOSE ASPECTS OF HER HAS SERVED ME WELL BEYOND THE INITIAL PROJECT." —**Vita Ayala**, writer, *Suicide Squad Most Wanted: El Diablo & Amanda Waller #5* (2017)

**AMANDA WALLER IS THE COMPLICATED COMMANDER** of the Suicide Squad. Since her comic debut in 1986, "The Wall" has been ruthlessly taking charge, using her high rank in the US government, talent for deception, and incredible intimidation skills to get her way.

With her access to the imprisoned metahumans at Belle Reve Penitentiary, Amanda Waller assembles the Suicide Squad from some of the most evil criminals in the DC Universe. Waller can send her teams of expendable prisoners into the most deadly and dangerous situations, and if they survive, Waller promises leniency in the remaining prison sentences. She has an incredible skill for providing the perfect motive to convince each of her convicts to join the team, and she is never denied a deal.

Formally known as Task Force X, the Suicide Squad's secret missions fall loosely under the umbrella of national security, though the unlawful techniques used to accomplish those missions would never be officially condoned by the government.

The goal-oriented Waller is uninterested in morality, completing missions in efficient and irreversible fashion despite the consequences. Her missions and means are not strictly heroic or villainous, so she swings between ally and antagonist of the DC Universe's proper Super Heroes. Batman even partners with her in some stories. Though Waller's morality may be dubious, her leadership skills are indisputable.

Perhaps because of her rough past, nothing in her work as leader of the Suicide Squad fazes her. Waller grew up in a housing project in Chicago and as an adult, her husband and children were murdered. But she rises from the ashes of a tragedy to get her doctorate degree in political science and becomes one of the most important, though clandestine, people in government.

Often depicted wearing skirt suits and bold jewelry, plus-sized Waller is able to portray her own brand of femininity alongside her strong, dominant personality. She leads some of the highest-powered metahuman villains, and stands up to the pompous politicians who try to wield control over her. She may not have superpowers herself, but with an army of metahumans at her disposal, Amanda Waller is one of the most powerful African American woman in the DC Universe.

# BIG BARDA

"BARDA IS A GREAT EXAMPLE OF HOW CHOICE AND RESPONSIBILITY DOVETAIL . . . BARDA TOOK HER BLUNT-FORCE GIFT AND HAS CHOSEN TO USE IT FOR THE GREATER GOOD. SHE'S MORE THAN JUST A MEGA-ROD. SHE'S A POWERFUL ALLY WITH A LOT OF HEART. THAT'S BOTH POWERFUL AND INSPIRING—AND APPLICABLE IN A REAL-WORLD WAY."

—**Misty Lee**, voice of Big Barda, *DC Super Hero Girls*

**BIG BARDA WAS SPECIAL FROM HER CONCEPTION.** Despite the fiery hellscape of the planet Apokolips, her mother fell in love, and from that love Big Barda was born. Though Big Barda was the only baby on Apokolips conceived in love, her fate would be the same as any other. Like all the children of the New Gods (powerful alien beings), Darkseid took baby Big Barda from her mother. After a brief stint in the Gestatron Lab, Big Barda was given to Granny Goodness, who would train her to be one of the most feared warriors on Apokolips.

As a warrior, Big Barda excelled at hand-to-hand combat and battle strategy. With her signature Mega-Rod, she could inflict a truly unique level of blunt force trauma on her enemies. Her immense talents were mirrored by her large size, as she towered over her foes and fellow warriors.

Granny Goodness selected Big Barda as her first pick for the new battalion that would become known as the Female Furies. As a squad leader in the Female Furies, Big Barda's skills shined. She led her troops to victory over anyone who dared come in their path, leaving only a trail of Apokoliptian destruction.

Like her mother, Big Barda fell in love. When she met Scott Free (aka Mister Miracle), the love she had been burying inside of her blossomed. But her feelings for Scott couldn't coexist with being an Apokoliptian warrior. Together they escaped the bloodstained battlefields of Apokolips for the greener pastures of Earth.

On Earth, Big Barda and Mister Miracle married, cast off the villainy of their upbringing, and established themselves as heroes. In her marriage, Big Barda consistently subverts stereotypes, as she often saves her Super Hero husband and is the alpha of their relationship. Being the bigger, stronger, and more aggressive of the couple, she takes it upon herself to protect Mister Miracle.

Throughout her comic history, Big Barda has been part of several crime-fighting teams, including the Justice League and Birds of Prey. As a hero, she proves that our past doesn't have to determine our future. Though she was trained to be the epitome of villainy, she has become one of villainy's greatest conquerors, using her combat skills for good instead of evil.

# BUMBLEBEE

"DOESN'T MATTER IF I'M BIG, SMALL, OR SOMEWHERE IN BETWEEN BECAUSE I'M BEATING YOU WITH MY BRAINS!" —**Bumblebee**, *DC Super Hero Girls: Search for Atlantis* (2018)

**SOARING ON THE PAGES OF *TEEN TITANS*** in 1976, Bumblebee was one of DC's first African American female heroes. This buzzworthy hero was originally a member of the Teen Titans and later joined the Doom Patrol.

Karen Beecher was a normal young woman with an incredible talent for tech, superior science skills, and an astonishingly high IQ. She created a super-suit that gave her the ability to manipulate her size, fly, and shoot electric stings, as she took on the alias of Bumblebee, showing that even the smallest heroes can perform supersize feats. Assertive and gutsy, Bumblebee created her hero persona without waiting for permission or requiring a singular moment of divine inspiration or intervention. She's a self-made hero whose heroic potential was recognized by the Teen Titans, who recruited her to the team.

Though her suit imbues her with some powers, she is still mortal, and therefore vulnerable. When she faces super-villains and selflessly makes sacrifices to help others, she risks more than other Teen Titans who have enhanced healing abilities and invulnerability. Although her life is on the line, Bumblebee continues day after day, fight after fight, because of her innate, heroic drive.

As a top inventor in the science lab, Bumblebee outfits herself and her team members with her ingenious devices. After her retirement from the Teen Titans, Karen Beecher would continue this tradition as an inventor for S.T.A.R. Labs, making weapons and gadgets for active superheroes.

With her intelligence and ambition, Bumblebee became a Super Hero. But with her generosity and kindness, she sets herself apart by exponentially increasing her impact when she aids other heroes.

# GRANNY GOODNESS

"REMEMBER THAT TIME I DIDN'T LET YOU HAVE WATER FOR TWO WEEKS, BARDA? GOODNESS, YOU SCREAMED AND CRIED, LIKE A CHILD. BUT YOU WERE ALREADY FOUR! 'GRANNY, GRANNY, PLEASE!' YOU WERE ADORABLE. 'PLEASE, PLEASE, PLEASE!' HA! HOW TIME GOES BY. IT'S TRUE WHAT THEY SAY ABOUT RAISING CHILDREN. LONG DAYS. SHORT YEARS." —**Granny Goodness**, *Mister Miracle* #2 (2017)

CONTRARY TO THE SACCHARINITY OF HER NAME, Granny Goodness is anything but sweet. Sadistic, cruel, and manipulative, Granny Goodness runs the orphanage on the fire-and-brimstone planet of Apokolips and is obsessed with training her charges to become warriors who will appease her evil master, Darkseid. In her role as orphanage headmistress, Granny professes her affection for the youngsters in her care while simultaneously putting them through the darkest punishments and wickedest trials imaginable.

One of her favorite children to love and torture is Scott Free who, as an adult, will become the hero Mister Miracle. Despite being a Super Hero, Scott is still scarred by the unrelenting creativity of her torment, and the childhood trauma affects his mental health.

As a functionally immortal deity, Granny's advanced age and stout stature are belied by her strength and capability. Accomplished in the use of Apokoliptian weaponry and skilled in military tactics and hand-to-hand combat, Granny Goodness is a match for any superhero. With her army of trained orphans—many of whom have superpowers and proficiency in advanced, deadly weaponry—Granny is a nearly unbeatable force.

Her most noteworthy troop is the Female Furies, whom she has cultivated into the most brutal fighting force in Apokolips. These trained warriors, including Stompa, Mad Harriet, Speed Queen, and Lashina, unquestioningly carry out her will, even if the consequence is their own deaths. The planet's toughest warrior, Big Barda, belonged to the Female Furies until she was able to escape Apokolips—a betrayal that Granny Goodness will never forgive.

Created in 1971 as part of Jack Kirby's *New Gods*, Granny Goodness represented a new breed of super-villain. At that time, and often since, the majority of female super-villains conformed to a version of femininity seen through the male gaze. They were often women who had been scorned by lovers and were seeking revenge; voluptuous gals possessed by dark forces who needed a man's guidance to free themselves; dominant but sexually desirable women who should be tamed by a male hero; or jealous women who were the foes of female superheroes.

But Granny Goodness was different. Though still in the matriarchal role of child caretaker, Granny was irrepressible, indomitable, and unparalleled in her leadership power. She had no petty personal vendetta against the superheroes who would face her, but an overarching, unyielding devotion to evil incarnate. Granny Goodness is one bad old lady.

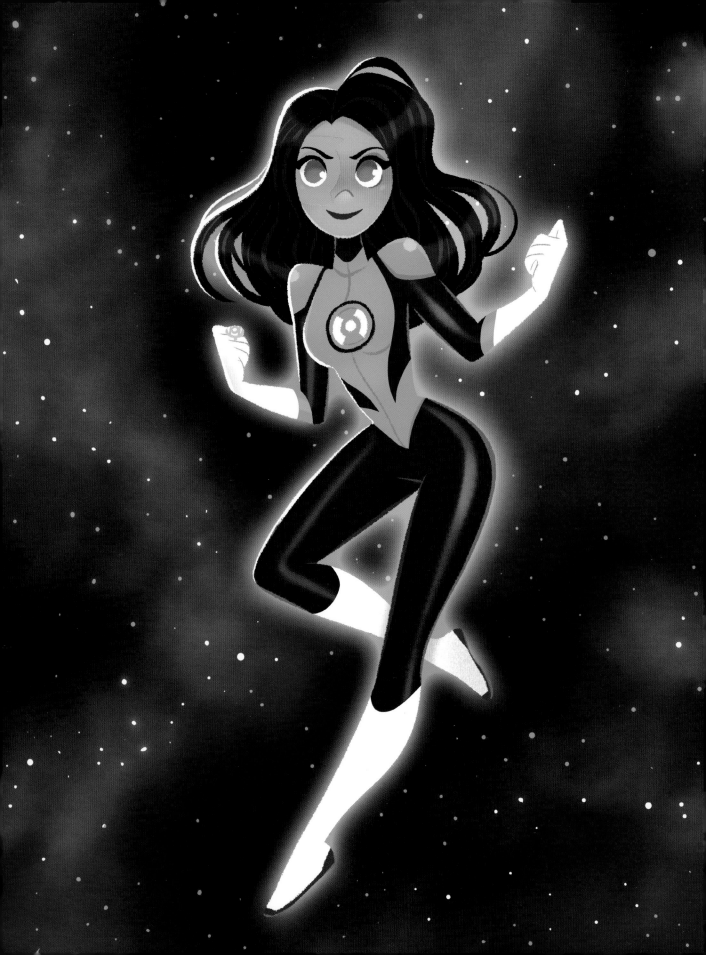

# JESSICA CRUZ

"WHEN I WAS A LITTLE GIRL, THERE WEREN'T HISPANIC SUPERHEROES IN MAINSTREAM MEDIA. A CHILD WHO SEES A SUPERHERO THAT REFLECTS THEIR OWN HERITAGE, CULTURE, AND UPBRINGING THEN HAS SOMEONE VERY SPECIFIC THEY CAN RELATE TO. IT SHOWS THEM WHO THEY CAN BECOME IF THEY ARE PASSIONATE, CARING, AND HARD WORKING. AND IT DEMONSTRATES TO THEM—JUST BY NATURE OF THEIR HERITAGE BEING FEATURED HEROICALLY IN THE MEDIA—THAT THEY ARE INHERENTLY WORTHWHILE AND BEAUTIFUL . . . JESSICA CRUZ WILL SPEAK TO A WHOLE NEW GENERATION OF HISPANIC CHILDREN, AND SHE WILL GIVE THEM CONFIDENCE TO BE EMPOWERED IN THEIR OWN SKIN AND CULTURE."

—**Cristina Milizia**, voice of Jessica Cruz, *DC Super Hero Girls*

**JESSICA CRUZ IS ONE OF THE NEWEST ADDITIONS** to the DC Universe, first appearing in a single panel of 2013's *Green Lantern #20*. With her relatability, authenticity, hopefulness, and skills with a Green Lantern power ring, she quickly became a member of the Justice League and also a fan favorite. Beyond her canon appearances, Jessica is also featured in the *DC Bombshells* and *DC Super Hero Girls* universes.

As the first Mexican American Green Lantern, and the first female Green Lantern to be a member of the Justice League, Jessica wields the power that smashes glass ceilings. Partnering with Simon Baz as the duo of Green Lanterns assigned to Space Sector 2814, Jessica brings a complex strength, determination, and conviction to the Green Lantern team.

Jessica's journey began when she witnessed the horrific murder of her friends. While Jessica escaped the mobster murderers, she couldn't escape the mental consequences of what she saw. Suffering from extreme post-traumatic stress, Jessica sequestered herself from society, but she was unable

to hide from the Ring of Volthoom, a wicked, fear-feeding power ring that seeks her after her trauma. The ring took over her body, inducing more of the terror that could strengthen it. With Batman's help, Jessica was released from the ring's control. When Jessica learned how to control the ring, she took on the mantle of the Green Lantern.

In the Lantern mythology, each Lantern color is connected with a central emotion—love fuels the Violet Lanterns, while the Yellow Lantern's core emotion is fear. However, the Green Lantern revolves around willpower, a mental ability rather than strict emotion. Even though she doesn't always feel like it, Jessica has willpower in spades, training her warrior spirit day after day and triumphing over fear as she battles anxiety. With her Lantern ring on her finger and will-power in her mind and heart, Jessica is able to take on the strongest villains in the universe.

I've had the opportunity to write Jessica Cruz as both her main universe, adult version, in *Justice League* #22 (2017), and as teenager in the *DC Super Hero Girls* animated shorts and *Spaced Out* graphic novel. No matter her age, her most noteworthy characteristic is her courage in the face of her constant battle with post-traumatic stress and anxiety—a persistent fight against her own brain that started before her superhero days.

Mental health issues are often stigmatized and exploited in comics—they're seen as the antithesis of the superhero ideal, a personal failure incompatible with bold, immediate heroic action. However, Jessica Cruz shows us that having an anxiety disorder does not eliminate the possibility of being a hero. Acting heroic through her anxiety makes her an even stronger hero.

Her post-traumatic stress is not something she overcomes or "wins." It's not a part of her broken backstory to be neatly left behind when she becomes a

hero. It's an ongoing, everyday fight for her own mental health. She's even had storylines that include her visiting her therapist while juggling her Super Hero duties. As a Super Hero, Jessica shows people struggling with mental health disorders that functioning in day-to-day life and taking care of yourself can be some of the most heroic victories.

While her anxiety is a constant struggle for her character, Jessica proves herself a capable warrior and a strong, platonic partner to Simon Baz. She is quickly thrust into the top tier of crime-fighting when she's inducted into the Justice League, and even though she lacks experience, she deserves to be there. The Green Lantern ring chose Jessica to protect Space Sector 2814, and, therefore, she is undeniably right for the job.

Jessica is authentic and vulnerable as she deals with her fully human problems and her life as a Super Hero. "The trait I find most inspiring about Jessica Cruz is her ability to grow beyond her fears since her drive to help others is so strong," said Agnes Garbowska, artist on *DC Super Hero Girls: Spaced Out.* "Jessica lacks confidence in herself and her skills, but this does not stop her from working hard to overcome her greatest obstacle, which is herself. Through her journey, she learns from those around her and grows so much. I think this is something we all can aspire to."

Jessica shows us that being a Super Hero is never glamorous, is rarely amusing, but is always worth the effort. She's not fearless—she's courageous.

# MERA

"I AM THE QUEEN OF ATLANTIS—AND I WILL NOT ABANDON MY KINGDOM!" —Mera, *Aquaman* #41 (2018)

SINCE FIRST SWIMMING INTO THE SCENE in *Aquaman* #11 in 1963, Mera has been the mighty Queen of the Sea, a powerful water warrior, and the true love of Aquaman. Mera controls the water itself, unlike Aquaman, who exerts control over the beings that live in the sea. With powers of hydrokinesis, hydrokinetic flight, and cryokinesis (power over ice), in addition to her super-strength and enhanced durability, the ocean is at Mera's command.

Mera's water powers are unrivaled and come in handy in a variety of circumstances—even a humid day is a potential weapon. With her unique skill set and extreme power, Mera is occasionally called up to the ranks of the Justice League.

Like Aquaman, Mera can survive both in and out of water. Her fishy beau is more landlubber than she is, since he is half-human while she's fully Atlantean. Mera spent her life underwater while Aquaman grew up on land. When visiting the top world, Mera is a literal and figurative fish out of water, unaccustomed to many human traditions.

Mera spent her childhood in the underwater dimension of Xebel. She was raised in a place tainted with anti-Atlantean sentiment and trained as a warrior and assassin who would take down Atlantis. But Mera finds her star-crossed lover in the underwater palace in Atlantis—and he happens to be the king of the city. After falling in love with Aquaman, Mera converts to the Atlantean side and eventually becomes the queen of Atlantis.

"Mera has to decide whether or not to choose her people or her heart," said Danielle Paige, writer of the *Mera: Tidebreaker* graphic novel from DC Ink. "Her story is epic and filled with conflict and darkness. And the stuff that DC legends are made of. She is a warrior, a daughter, and a friend first, and not just Arthur's love."

As Queen of Atlantis, Mera is deeply protective of her kingdom, even if that comes at the cost of humans. She's less trusting of humans than her husband is, and she's willing to war with humanity if it's for the good of Atlantis. She can be righteously indignant, unashamed of her anger, and brazen in all the best ways.

With her classic green costume, streaming red hair, and impressive stature, Mera's alluring physical presence has been consistent from her first comic appearance to her many animated appearances to Amber Heard's portrayal of the iconic character in *Aquaman* (2018). Complementing her always stunning looks, the character has evolved into an intriguing leader with quick temper and awesome powers, who truly rules as Queen of Atlantis.

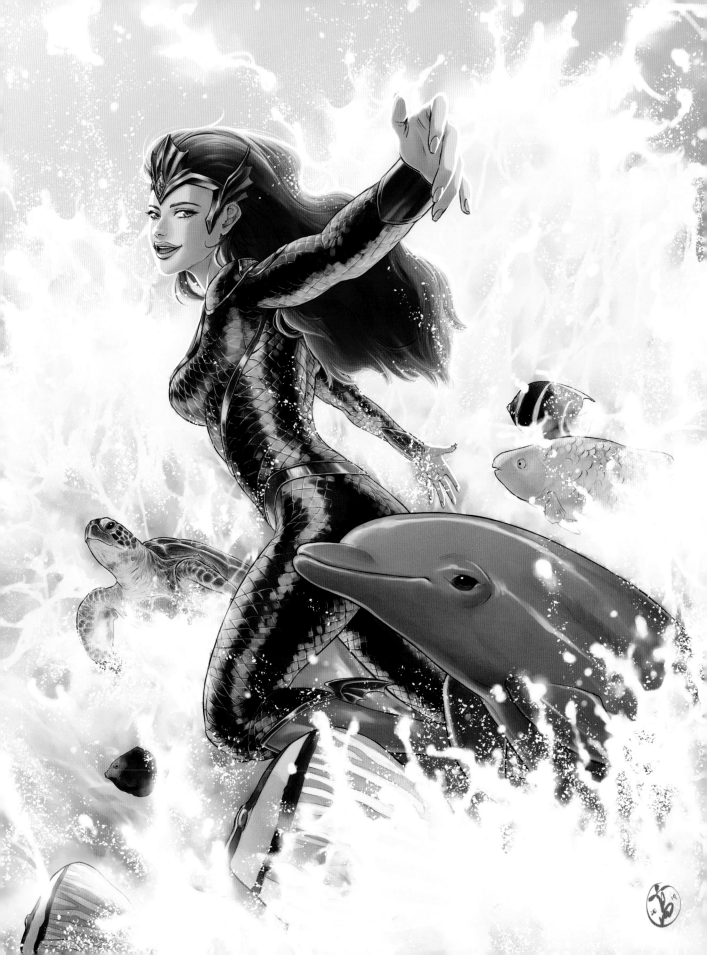

# RAVEN

"AS A FOUR-YEAR-OLD WHO WAS ATTRACTED TO HORROR, SCI-FI, AND ALL THINGS DARK IN GENERAL, I FOUND IT DIFFICULT TO RELATE TO OTHER GIRLS MY AGE, YET I WASN'T A COOKIE-CUTTER DEFINITION OF WHAT PEOPLE SAW ME AS. I STILL LIKED TO GO OUT OF MY WAY TO HELP PEOPLE IN NEED AND OCCASIONALLY BE PART OF A TEAM. RAVEN IS EXACTLY ALL THOSE THINGS I WOULD HAVE RELATED TO AS A LITTLE GIRL. SHE HAS HER DARK RESERVED SIDE AND THE OCCASIONAL CHATTY SIDE. AS WE ALL KNOW, REPRESENTATION IS IMPORTANT. I FEEL SEEING A DARK CHARACTER LIKE RAVEN BEING PRESENTED AS SHE IS WOULD HAVE CHANGED HOW I SAW MYSELF AS A KID FOR THE BETTER."

—**Monica Kubina**, colorist, *Convergence: Justice League* (2015) and *DC Super Hero Girls* (2016–2018)

**WITH HER MYSTERIOUS EYES SHIMMERING** from the shadow of her dark hood, Raven has been a member of the Teen Titans since 1980. Raven is an empath whose powers are fueled by, and responsive to, emotion. Her magic-based powers include telepathy, teleportation, telekinesis, and soul projection. With her goth-girl vibe and dark sense of humor, Raven is the perfect counterpoint to sunny Starfire, the other most prominent female member of the Teen Titans.

Raven's father is the evil demon Trigon. Though Raven fears that she will take after her father, she is far more than her genes. Her ancestry provides the basis for her magic abilities, but she chose to use her powers for good and counteract the terror of her biological father. Despite Trigon planning to use her to extend his evil influence, she's able to go against him to be a hero.

Unlike some other female heroes who represent a cheerful and easy-going version of femininity, Raven is serious, thoughtful, and multifaceted. As an empath, she is unable to shrug away the horrors of humanity that she sees during her heroic adventures, but she also can't become overly emotional in her reaction or she risks losing control of her powers. Forced to walk a delicate line between feeling deeply and acting unemotionally, Raven rises to be one of the most fascinating women in the DC Universe.

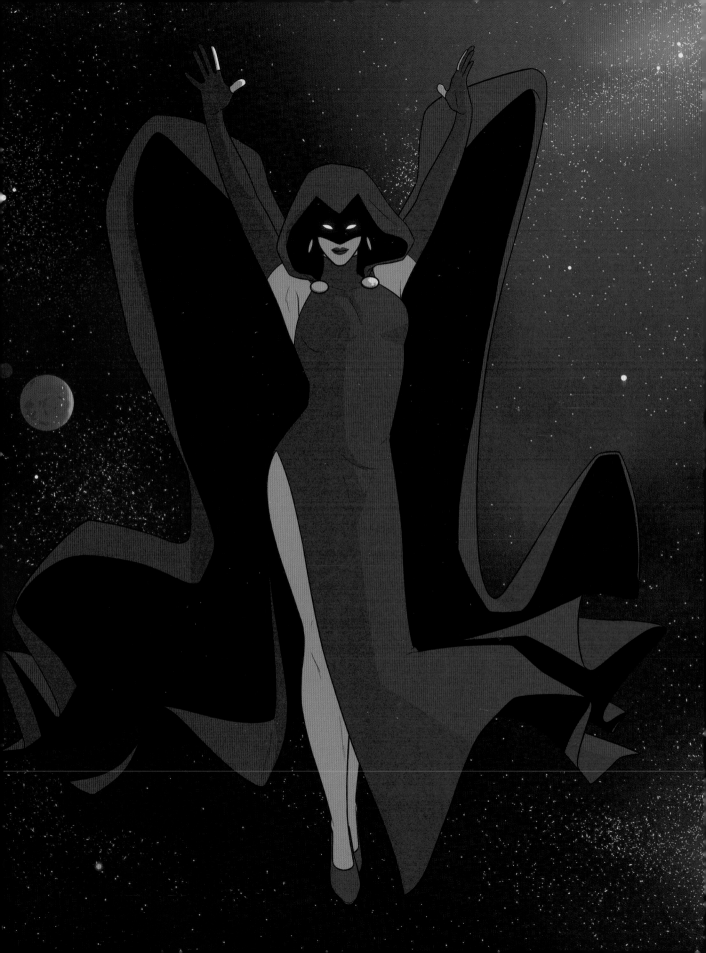

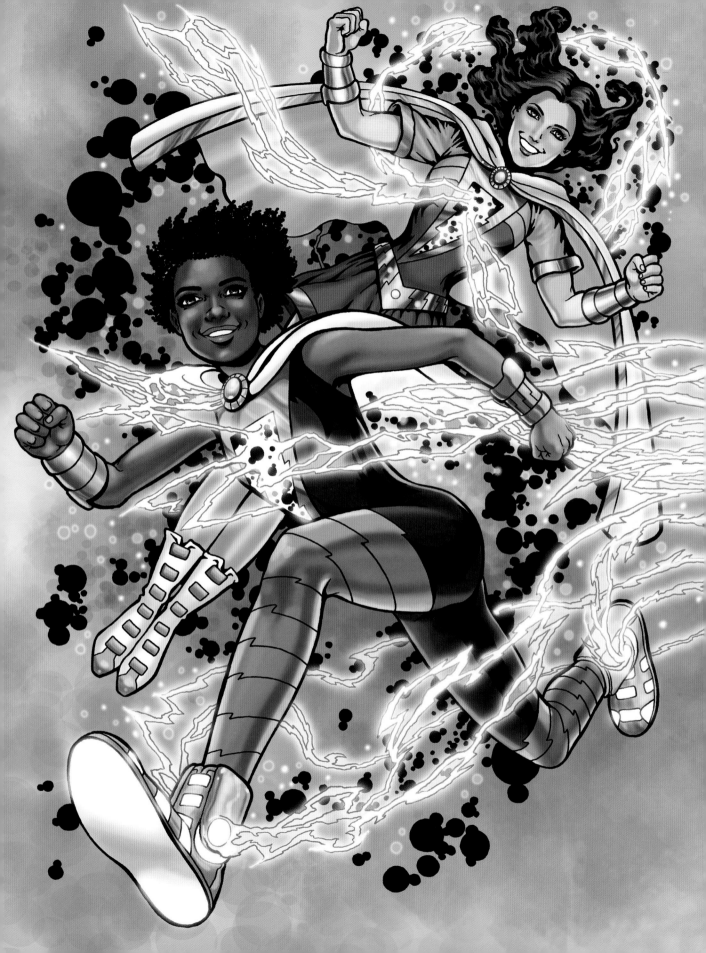

# SHAZAM FAMILY: MARY AND DARLA

> "I CAN'T WAIT!"
>
> —Darla Dudley, *Shazam!*

**FIRST APPEARING IN *CAPTAIN MARVEL ADVENTURES* IN 1942**, Mary Batson is one the earliest female Super Heroes, and one of the first examples of a female spin-off of a male hero. Like her brother, Billy (aka Shazam), Mary could transform into a costumed hero by saying the word "Shazam!" But instead of receiving her powers from male deities as her brother did, the original version of the character received her powers from female patrons: Selena (grace), Hippolyta (strength), Ariadne (skill), Zephyrus (fleetness), Aurora (beauty), and Minerva (wisdom).

The current Shazam family storyline launched in 2011 during the events of the *Flashpoint* miniseries. In this new iteration, the Shazam family is made up of foster siblings Billy Batson, Mary Batson, Pedro Peña, Eugene Choi, Freddy Freeman, and Darla Dudley. Now, Darla, Mary, and their brothers each form an important part of the Shazam family and use their powers to promote good in the universe.

Mary is a welcoming, wise teen with a soft spot for animals. Even before she had powers, she rescued her pet rabbit from a laboratory. Fiercely protective, she looks out for and guides the younger members of the family. She stands up for others no matter how big the bad is that she's standing up to.

Darla is an enthusiastic African American teen who throws herself into everything she does. Sensitive, scrappy, and intelligent, Darla is the youngest member of the family. Unlike the other Shazam members, Darla physically remains a teen while in her Shazam form.

Mary (Grace Fulton) and Darla (Faithe Herman) made their cinematic debut in 2019's *Shazam!*

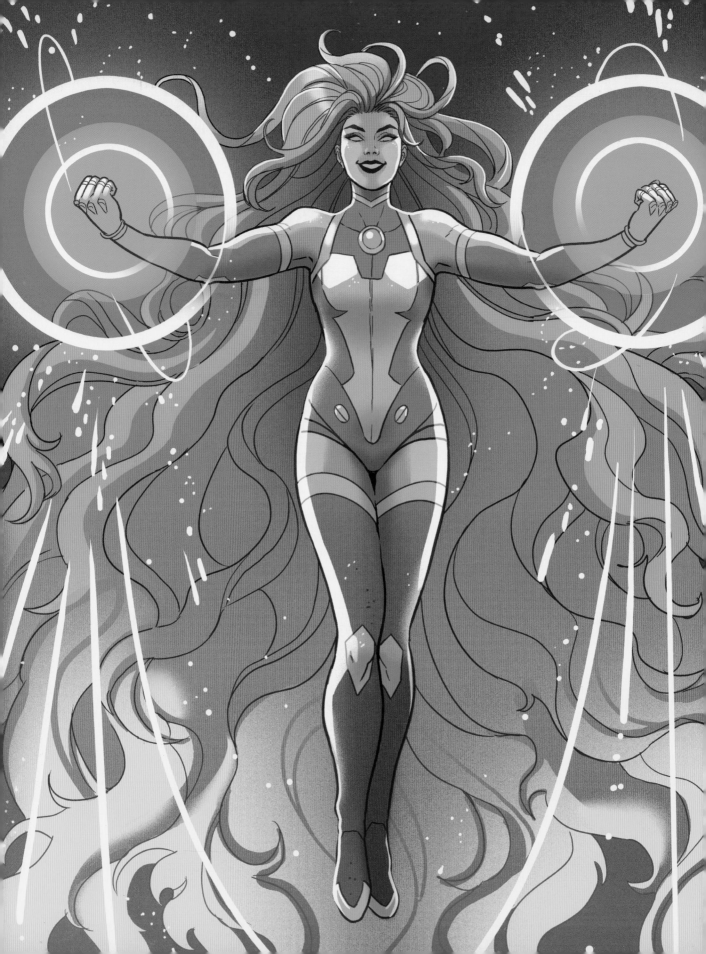

# STARFIRE

"EVERYTHING STARFIRE SAYS COMES FROM THE HEART. HER VOICE IS MADE OF LOVE AND AIR. WHETHER SHE'S THE STARFIRE FROM THE ORIGINAL *TEEN TITANS* SERIES, WITH HER RIGHTEOUS FURY, OR JUST BEING SILLY ON *TEEN TITANS GO!,* STARFIRE IS ALL INNOCENCE AND INTEGRITY. SHE'S FINE WITH BEING DIFFERENT AND HER DIFFERENCE GIVES HER COMPASSION FOR OTHERS." —**Hynden Walch**, voice of Starfire, *Teen Titans Go!* and *DC Super Hero Girls*

**BORN PRINCESS KORIAND'R** on the planet Tamaran, Starfire was forced to flee her home when her jealous and vengeful sister, Komand'r, aka Blackfire, staged a coup for Starfire's throne. But Tamaran's loss is our gain when the displaced Princess Koriand'r arrives on Earth, takes the alias of Starfire, and joins the Teen Titans. With love as her core value, Starfire provides a healthy dose of heart to the team, helping guide them with the most compassionate and caring strategies.

She's been a member of the Teen Titans from her creation in 1980, but Starfire is portrayed as more adult-like than her teammates, bringing a steadfast, mature perspective to the crew. "She is incredibly intelligent and a badass warrior, but is new and inexperienced to the ways of planet Earth," said Amanda Conner, writer and artist on *Starfire* (2015–2016). "One of the most entertaining things is to watch her navigate all of the strange and different Earth customs. And then to watch Earth humans react to all of her strange and different Tamaranean customs."

Thanks to her Tamaranean DNA, Starfire can absorb solar radiation and convert it into super-powered energy. With flight, super-strength, language assimilation via contact, and starbolts that fire from her fists, Starfire is one of the strongest characters in the DC Universe. She was a warrior on her home planet, and she puts these skills to use as a protector of Earth.

Though she's most closely associated with the Teen Titans, various timelines and reboots have shown her fighting together with Red Hood and the Outlaws, the Outsiders, the Amazons, and the Justice League.

Starfire is enjoying a boost in mainstream recognition thanks to her inclusion in the popular, lighthearted animated series and feature film *Teen Titans Go!* In this cartoony incarnation, Starfire has gained a few feet of fabric for her costume and has lost her perfect assimilation of language from the original comics, but remains true to her empathetic center. Her signature compassion and kindness shine through her comically convoluted speech pattern.

# STARGIRL

"PREPARE TO GET YOUR BUTT KICKED—STAR SPANGLED KID STYLE!"

—**Stargirl**, *Stars and S.T.R.I.P.E.* #1 (1999)

WHEN TEENAGER COURTNEY WHITMORE acquires the Cosmic Converter Belt and Cosmic Staff, she adopts the identity of Stargirl and joins the Justice Society of America. The Cosmic Converter Belt grants her enhanced strength, speed, and agility, which boost her naturally earned kickboxing and gymnastic skills. Additionally, her powers include flight, energy manipulation, and shooting star projections, making her a force to be reckoned with.

Her journey into the Super Hero society begins when Courtney begrudgingly moves with her mom and new stepdad, Pat Dugan, to the rural plains of Blue Valley, Nebraska. There, she discovers that her stepdad used to be known as Stripesy, the first adult sidekick to a teenage hero. Unhappy with her mom's new marriage and planning to mock her stepdad, Courtney takes the costume, but her scheme goes awry when a supervillain attacks. Wearing the costume, she must step up as a hero.

Following this auspicious introduction into the spotlight, Courtney catches the attention of Starman, who bequeaths his Cosmic Staff to her, which completes her transformation from regular high schooler to full-fledged heroine.

However, Courtney struggles to manage her teenage life with her duties as a superhero. She starts out as a rebellious, impulsive kid, but through her cosmic comic journey, she matures into a capable hero who learns and grows during every battle.

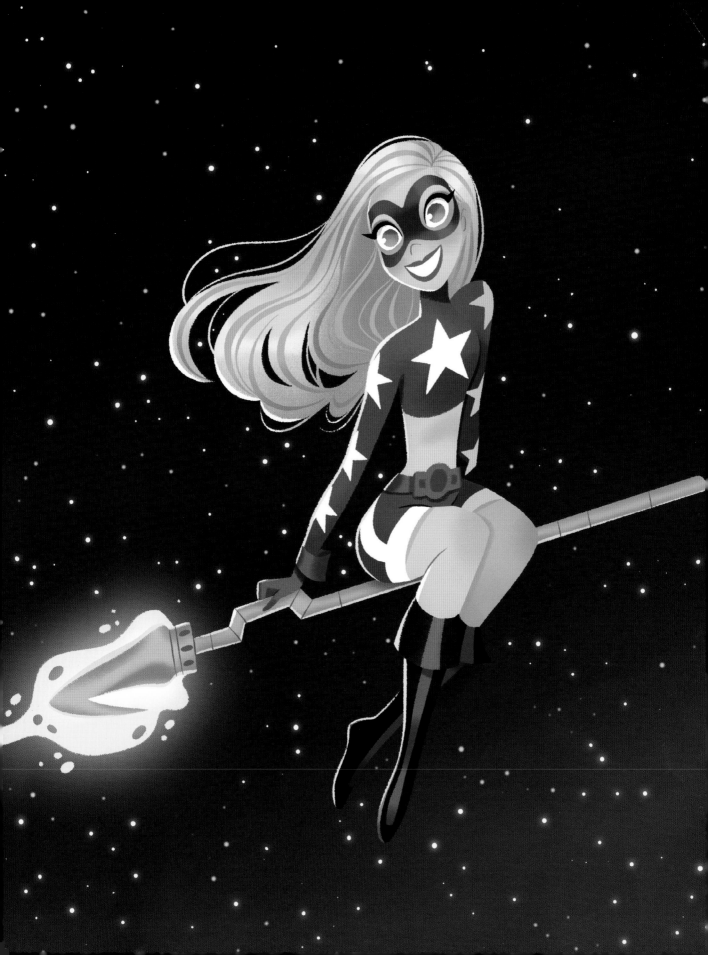

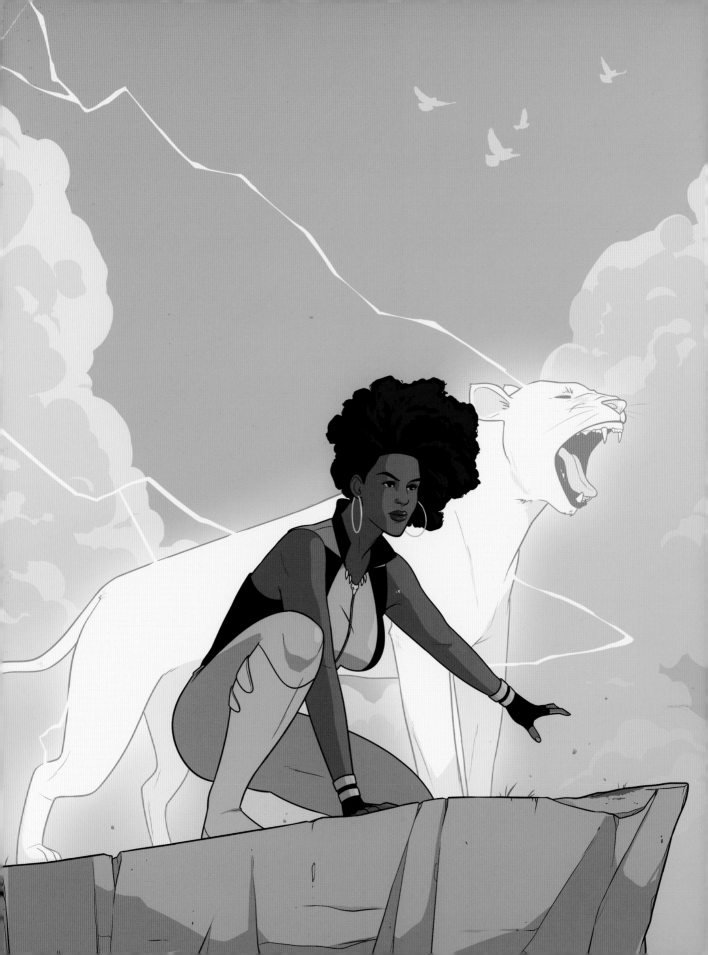

# VIXEN

"ONE BACK WILL NEVER HOLD UP A BILLION LIVES. NO MATTER HOW
STRONG. BUT IF BILLIONS HOLD UP THE PERSON NEXT TO THEM?
WE'RE ALL STANDING." —**Vixen**, *Justice League of America #4 (2017)*

**VIXEN RUNS WITH THE SPEED OF A CHEETAH**, fights with the strength of a hippo, and soars like an eagle. But before she wore the Tantu Totem, which allows her to access and embody the abilities of any animal, living or dead, she was a regular African woman named Mari Jiwe McCabe.

Mari grew up in the fictionalized African nation of Zambesi, and she derives her powers from her African heritage. Her status as an African native instantly makes her distinct among the DC pantheon, which is largely Western Hemisphere–centric.

While growing up in her village, Mari learned the family legend of the Totem, a fox head–shaped artifact that grants its holder animalistic abilities. The magic Totem, which is native to Ghana and tied to the legend of the trickster-god Anansi, wound its way through generations until it was destined for Mari's family. After being briefly usurped by Mari's uncle, Mari takes control of the Totem and becomes the costumed crime-fighter known as Vixen.

Leaving her homeland to establish a base in the United States, Mari became a part-time model and full-time Super Hero. Throughout her publishing history, Mari has defended the innocent of Gotham City, Metropolis, and Hub City, and her work occasionally takes her to her home continent.

Vixen was intended to be DC's first solo series starring a black female metahuman. The first *Vixen* book was slated for 1978, less than two years after the appearance of Bumblebee in *Teen Titans* and five years after the debut of

Nubia in *Wonder Woman*. However, a company shake-up caused the sudden cancellation of dozens of books, and the solo *Vixen* series disappeared from the DC roster before its first issue could be released. The character of Vixen would reemerge a few years later in *Action Comics* #521 (1981).

Since her anticlimactic initiation into the DC Universe, Vixen has been published primarily in team books, including *Suicide Squad* and *Justice League of America*. In 2008, Vixen starred in an eponymous five-issue limited series, written by G. Willow Wilson, that explored the character and the source of her power on a deeper level.

In her solo series, Mari realizes that her powers aren't solely the result of the Totem, but rather that the Totem enhances her innate powers. "All these years I was afraid . . . afraid of what would happen if I lost control. I felt like a fake around the other leaguers . . . they're so confident because their powers are inborn. Part of them. But it was fear itself that held me back. It kept me from realizing that my powers are a part of me. The totem doesn't control me . . . I control it," Vixen says in *Vixen* #4 (2009).

Whether a result of the mystic Totem or inherited innate abilities, Vixen's powers are unique among the DC heroes. While many famous heroes' identities are animal inspired—think Batman and Catwoman—Vixen's powers are directly linked to specific animals. However, she's not possessed by an animal, nor is she part-animal like the Cheetah. While her powers are animal-based and open to the entire animal kingdom like Beast Boy's, she doesn't shapeshift to take the physical form of the animal whose powers she uses.

Her powers are most similar to Animal Man's, who can possess the powers of nearby animals, although Vixen's powers are broader, allowing her to access the power of any creature, living, dead, or even mythological—she once took on the power of a dragon. In addition to taking on the abilities of animals, Vixen

holds sway over animals around her and can make them resist their natural predatory instincts.

While these amazing abilities allow her to be a hero, her relationship with her powers is precarious, and she is not always able to control them. When she becomes emotionally overwhelmed, Vixen loses control of her powers. Additionally, she may unintentionally absorb power from animals, taking on their rage and violent behaviors.

Vixen is one of the few female heroes to regularly be portrayed with short hair. Sporting a cropped pixie cut, she stands out among the pack. She has also been shown to have cropped natural curls, such as in *Justice League of America: Vixen* #1 (2017), which launched her story in the Rebirth continuity.

Though she can take on the power of any animal, Vixen is at her most interesting when she's human. Her struggle to bury her emotions, her quest to fit in with the Justice League of America, and her sorrow when dealing with the death of her mother help make her a rich, complex character.

Demonstrating the same resilience she uses in her work, Vixen overcame the obstacle of cancellation before her first issues to become one of the most prominent female heroes in the DC Universe. As Vixen continues to capture the imagination of readers, she proves that she is a hero who is born to roar!

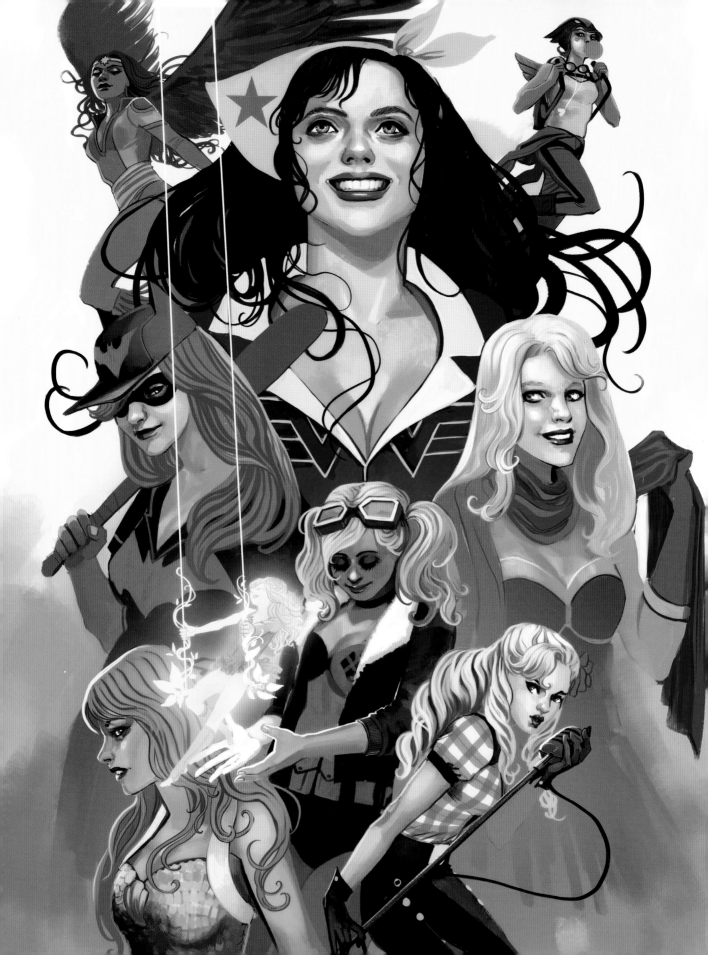

# MARGUERITE BENNETT AND THE BOMBSHELLS

---

"HOW ABOUT A JUSTICE LEAGUE OF OUR OWN?"

—**Kate Kane**, *DC Bombshells* written by Marguerite Bennett

---

**OF THE WOMEN PROFILED IN THIS BOOK**, Marguerite Bennett is the newest to the DC family, but she's already left a lasting imprint in the company's catalog with the alternate-history, female-led series *DC Bombshells*, which launched in 2015. Set in the World War II era, *DC Bombshells* unites several female characters from across the DC Universe, bringing them together in a unique, bold collection of stories. "Heroines! WWII! Ant Lucia art! Alternate histories! All my favorite things!" said Bennett, recalling when she first heard about the project. "After [the editor] asked for a two-to-three page outline, I submitted an outline eighteen pages long, which covered my proposal for as many issues."

Though it seems fated that Bennett would write the series, she hadn't initially considered comics as a career, despite her love for the medium. While studying writing at Sarah Lawrence College, however, Bennett took a graphic novel writing class that would change the course of her life. As a determined and prolific student who worked hard to hone her talent, Bennett quickly launched her career and has been writing for DC ever since.

When Bennett was approached about a series based on the popular Bombshells line of statues from DC Collectibles, she was immediately taken with the idea's potential to combine many of her favorite things. "I dove in with a passion," recalled Bennett. "All my parents were history professors or teachers in some capacity, and I was very spoiled in my upbringing, hearing stories of the Civil War and Alexander at Thebes and the Siege of Leningrad when I was only a child." Each of the one hundred digital issues showcased Bennett's stellar ability to combine her knowledge of history with compelling stories.

*DC Bombshells*' main cast includes Batwoman, Wonder Woman, Supergirl, Stargirl, Zatanna, several Batgirls, and a diverse supporting cast of reimagined existing characters and exciting new characters. With Bennett's storytelling craftsmanship, each character shines. "No heroine was left to fulfill the role of 'the girl' on the team," said Bennett. "They could be fierce, funny, crafty, clever, kind, ferocious, vengeful, compassionate, anxious, desperate, brave—motivated by so many different needs, drawn from so many different countries—they were each allowed to be themselves, instead of handmaidens and helpmeets in another hero's journey. No woman was saddled with the burden of representing all womanhood—they owned themselves alone. Of this, if nothing else, I will always be most proud."

Bennett collaborated with several female creators during the *DC Bombshells* run, including Marguerite Sauvage, Mirka Andolfo,

and Laura Braga, and *DC Bombshells* was often the title with the most women credited in DC's catalog. According to Bennett, the female team "brought a tremendous amount of authenticity and passion for the series, and a locus for women who long to see themselves reflected sincerely and joyfully in the histories from which we are so often erased. We felt so confident in our mission and vision; we encouraged one another endlessly, defended and supported one another, guided one another through the trials of a series that ran for the equivalent of 65 standard issues."

From the beginning of the series, fans responded to Bennett's vision, making it a breakout success. Beyond the retro designs, historical accuracy, and superhero fun, Bennett hopes readers "find what they are looking for. I hope they tell their own stories and never let themselves be removed from the narratives of their own lives. I hope they realize that history is in motion all around us and that each 'Never Again' begins 'Right Now.' I hope they find assurance in their presence, their identities, reflected in art as in life, offering validation, offering presence."

# BEHIND T

E SCENES

# KAREN BERGER

Karen Berger began working for DC Comics in 1979, and during her three-plus decades with the company, she profoundly changed mainstream comics with the founding of Vertigo Comics, the edgier imprint of DC Comics. With more mature themes, darker stories, and a fearlessness in integrating political points of view, Vertigo permanently impacted the industry, making way for new stories and new storytellers. Through her tenure, Berger edited some of the most critically acclaimed and bestselling comics of all time, including *Sandman*, *V for Vendetta*, and *Hellblazer*.

In addition to her trailblazing work on the Vertigo line, Berger also edited some of DC's more traditional Super Hero titles like *Amethyst, Princess of Gemworld*; *Wonder Woman*; and *The Legion of Super-Heroes*. No matter what character or line she's working on, her commitment to exploring complex ideas, showcasing new talent, and expanding the world of comics is evident on every page.

# BOBBIE CHASE

As Vice President of New Publishing Initiatives & Talent Development, Bobbie Chase has worked in many capacities at DC. Alongside Diane Nelson, former president of DC Entertainment, Chase launched the Talent Development program, which brings new voices into the DC Comics family through the Writers and Artists Workshops.

In these major roles, Chase is diversifying and expanding both the talent behind the scenes and the readers of the books. "Comic books have been around for a very long time," said Chase. "They were started by a small group of people for a very different audience—not a very diverse audience, mostly male. And we've discovered over the years we have a large female readership, and we have a large readership who are more diverse than the white, male superheroes."

# JANICE CHIANG

Boundary-breaking Janice Chiang has been lettering comics for more than four decades. She's lettered tens of thousands of pages, and her prolific work includes *Batman*, *Superman Family*, *House of Mystery*, and the *DC Super Hero Girls* graphic novel series.

In the late 1970s when Chiang had finished her education in fine arts, she found her way into the comic book industry. "You have a dream and you have reality. And somewhere between the two will be the path you walk. There can be forks on the road, and you really have to trust your instinct about which way to go," said Chiang. When she began pursuing a career in comics, society was still reluctant to see women in certain roles. As Chiang recalls, "When I started in the industry, it was predominantly male. There was no way around it."

Growing up as a first-generation American with Chinese immigrant parents during the challenging Cold War years affected the way Chiang pursued her art. "My parents would say, 'You can't make waves.' It's a really fine line. How do you express yourself when you can't make waves? So my sisters and I, we just plowed into our art."

The longevity of Chiang's career is a testament to her resilience, her immense talent, and her ability to adapt to the changes and new trends in comics. After decades of lettering by hand, Chiang was a pioneer in creating her own fonts, which she uses when lettering digitally.

Whether working by hand or digitally, Chiang's background in fine art is evident in the elegance of her lettering, which is the invisible art on the comics page. "Lettering is reading the art, facilitating the storytelling. We reflect but we don't get in the way. It's really subtle. Good lettering, you don't see it all. Really bad lettering, you know right away," said Chiang.

"Janice really is a lettering artist," said Bobbie Chase, Vice President of New Publishing Initiatives & Talent Development at DC, who has worked with Chiang on numerous projects.

After working on thousands of comics, Chiang has only recently gotten some of the recognition she deserves, earning multiple awards for her lettering in the past few years because of her consistently exceptional output. After forty years, Chiang is still growing and holding herself to high standards. The key to her continued success? "I'm the hardest client to please."

# RAMONA FRADON

"When I see Ramona Fradon at a convention," said Marie Javins, Executive Editor at DC Comics, "I rush over to buy her sketches. She's an icon—one of the first women to regularly draw superhero comics. She and her contemporaries remind me that women have always been in comics. And she didn't just draw existing characters— she co-created Aqualad and Metamorpho. That's badass! I hope I'm still as enthusiastic to be holding down a con table when I'm in my nineties."

Ramona Fradon has been professionally creating comic art since 1949 when, fresh out of art school, Fradon landed her first comics job at DC Comics drawing *Gang Busters* #10. From there she went on to be one of the most influential artists at DC. With her undeniable talent and determination, Fradon made a name for herself in an era when the few female artists who had careers in comics were often uncredited or underappreciated.

At just twenty-four years old, Fradon began drawing her first signature character, Aquaman, whom she would work on for more than a decade. Fradon was integral to the reinvention of Aquaman for the Silver Age, providing the original design for his sidekick, Aqualad, and illustrating Aquaman's Silver Age origin story.

After Aquaman, Fradon went on to co-create other new characters, including Metamorpho for *The Brave and the Bold*. With Metamorpho, Fradon created a unique, goofy, exaggerated design, which allowed her to incorporate her own style with a looser, more humorous approach. This fun style became the standard for her work in *Plastic Man* and *Super Friends* and was immensely influential to generations of comic readers and the up-and-coming artists who devoured her books each new comic book day.

With a career spanning more than six decades, Fradon continues to create art. Her latest book was published in 2012; and even at ninety-one, she actively accepts commission requests. She was inducted into the Will Eisner Comic Book Hall of Fame in 2006, a well-deserved honor for her immense contributions to the comics industry.

# PATTY JENKINS

Patty Jenkins made history as the first female director of a major superhero film when she helmed *Wonder Woman* (2017), which broke the record for highest-grossing film directed by a woman.

Under Jenkins's direction, Wonder Woman is portrayed as an aggressive leader who cannot be deterred from her mission. Jenkins brought to life a Wonder Woman who was equal in combat to the most skilled generals and had no reservations about being a warrior and a woman. With her deft directing skills, Jenkins imbued Wonder Woman with multidimensionality, allowing her to be sincere, trusting, and innocent without being naive. Plus, her action sequences rivaled those of male superheroes.

Starting her career behind the scenes as a focus puller, Jenkins understands her hero's plight as a woman in a male-dominated world. Only 7 percent of the directors of the top 250 grossing films of 2016 were women, but Jenkins is working to change that as she paves the way for female directors in the years to come.

With her contract for the *Wonder Woman* sequel, Jenkins set the record as the highest-paid female director, demanding a salary equal to her male peers. Closing this pay gap created a precedent for women in the industry. Jenkins is a hero and role model in her own right, inspiring countless female filmmakers with her confidence, leadership, and superior filmmaking skills.

# JENETTE KAHN

In 1976, at just twenty-eight years old, Jenette Kahn became the publisher of DC and, soon after, this wunderkind became the president and editor in chief—the first and youngest woman to ever do so. Leading DC Comics for more than twenty years, Kahn oversaw some of the most revolutionary titles in DC's history, the radical evolutions of its characters, and an innovative infusion of new talent.

"Although our characters are fictional, they have a fierce reality for our readers, and we knew that they and their stories not only were sources of inspiration but could also be agents of social change," said Kahn, who encouraged creatives to break boundaries in mainstream comics by diversifying casts and including subject matter that addressed serious themes. "We introduced gay characters, added stronger women and

more female superheroes, launched a line of multiethnic heroes written and drawn by multiethnic creators, and took on issues like gun control, addiction, and landmines."

Beyond broadening traditional mainstream superhero titles to include socially conscious stories, new characters, and talent, Kahn also pushed DC to embrace the darker side of the comics medium with titles like *Batman: The Dark Knight Returns*, *Hellblazer*, *Watchmen*, *Road to Perdition*, *A History of Violence*, *V for Vendetta*, and *Sandman*. She had a vision for the variety of genres and spaces that comics could inhabit. Her holistic approach to comics led to the launching of the adult-oriented Vertigo imprint, as well as focusing on kids' titles and animated series, like the groundbreaking *Batman: The Animated Series* and *Static Shock*. She set the tone for a new generation of comics, which would have reverberations not just in the DC offices but throughout the comics industry.

Kahn's achievements during her tenure at DC extend beyond the page. "I'm most proud of ensuring rights for our creators," said Kahn. "When I joined DC, artists and writers throughout the industry signed away all the rights to their creations. It was a supreme injustice, so we set about to right that wrong, guaranteeing credit and the return of artwork, and introducing royalties, reprint payments, and a share in merchandise, movie, and television revenue."

"WHEN YOU SEE SOMEONE LIKE YOU IN A DESIRED PLACE OF WORK OR A JOB, YOU BELIEVE THAT THE SEEMINGLY 'IMPOSSIBLE' CAN BE ACHIEVED. SEEING JENETTE AS THE FACE OF DC AND AN OUTSPOKEN FAN OF THE CHARACTERS WAS ESSENTIAL IN MY JOURNEY TO BEING AN EMPLOYEE HERE. SEEING A WOMAN AS AN IMPORTANT PART OF THE COMPANY I LOVED SO MUCH MADE IT SEEM POSSIBLE THAT I COULD ONE DAY BE WORKING ALONGSIDE HER."
—**Brittany Holzherr**, associate editor at DC

She further helped change the work culture inside DC by opening the ranks to women, diversifying the staff, and helping to create a more inclusive environment. "That DC was a men's club when I joined in 1976 is unsurprising since we were purveyors then of male fantasy, filling our comic book pages with idealized men our readers wanted to be like and the pulchritudinous women they wanted to be with," said Kahn. "But as an avid comic book reader myself, I knew that comics appealed to women too. If there were women on staff creating the comics they wanted to read, then our audience would widen and DC would become a more vibrant and welcoming place to work.

"I wanted the DC staff to be more diverse, to include not just women in all departments but people of color too. Most tellingly, the very fact that a woman was now heading the company suddenly gave permission to open the doors of our insular world and simply hire the very best person for each job," Kahn said.

In addition to advocating for women inside the company, Kahn expanded her reach by spearheading the Wonder Woman Foundation "to recognize and reward women who embodied our heroine's attributes—women taking risks, women pursuing truth, women advocating equality and peace, women helping other women." To launch the foundation, Kahn joined forces with Gloria Steinem, the renowned feminist activist. "It was to Gloria I turned to for her sage counsel and it was she, more than anyone, who helped to shape its mission," she said.

As a young woman, Kahn soared to an unprecedented position, and she is quick to acknowledge that: "My privileged position as the sole female president at Warner Communications was made possible by a wave of feminists whose activism was breaking down barriers." With her incredible contributions to DC both on the page and behind the scenes, Kahn joins their ranks in breaking down barriers for those who would come after her.

# ADRIENNE ROY

Adrienne Roy was one of DC's most prolific colorists. During her career, Roy was responsible for coloring more than 600 Batman Family comics, plus a myriad of others including *Wonder Woman*, *Action Comics*, and *Green Lantern*, and more than 150 issues of *New Teen Titans*. Roy has been credited in more *Batman* comics than anyone except Batman creator Bob Kane.

With her deft skill, Roy adapted to the style of each new book she took on to set the tone, create the mood, and enhance the stories with her striking colors. She excelled in multiple genres, easily shifting from the bright colors of comedy titles to the morose, shadowed lighting of dramatic Gotham City.

# NICOLA SCOTT

Nicola Scott has been lending her artistic talents to DC since 2006, beginning with *Birds of Prey* #100 (2007), which first paired her with her frequent collaborator Gail Simone. With her clean lines, focus on anatomy, and rich detail, Scott's interior art repertoire has graced the pages of some of DC's finest female-led titles, such as *Birds of Prey* and *Wonder Woman*, as well as some of the most notable male characters in comics with *Superman* and *Earth 2*.

Scott came to comics as a career after a lifelong obsession with comic book–based characters, particularly Wonder Woman. "I consider her my patron saint," said Scott, who was only four years old when she first encountered the Amazon warrior; but the experience stuck with her. "It was profound. It was the first time I had seen a female action character. She was jumping over cars. She was throwing bad guys around and she was deflecting bullets. It was the first time I saw a female character doing that, but she was also wearing this crazy costume, which I didn't compute properly," recounted the Australian native, who as a preschooler didn't recognize the American flag motif of the costume. "But it was bright and it was colorful and she was really beautiful and she was just handling the situation. And there's just such a sort of power fantasy in that for a kid."

When Scott was contemplating a career change as a young adult, her "patron saint" would once again inspire her. "I come from a creative family and having an artistic career is not a stretch," said Scott. She had an aptitude for drawing, but was struggling to find a creative outlet that suited her as a career. "I said in my head, 'If I had to draw the same thing all day every day, what would I want to draw?' And straight away I thought, 'I wish I could just draw Wonder Woman,' and instantly it was like a light bulb turning on."

This revelation led Scott to her local comic book store. Though she adored the popular characters in film and television, she hadn't been well-acquainted with the comic book side of the industry. "I really loved superheroes, but I just didn't get comic books because that felt like it was for boys," she recalled. However, once the idea of becoming a comic artist took hold, she immediately began to immerse herself in comics, figuring out how to pursue her passion.

Despite her intense research and talent, breaking into the industry wasn't easy. According to Scott, at the time she thought, "I'm on the wrong side of the planet. I'm getting the impression I'm the wrong gender because this was the very early 2000s and there were not a lot of high-profile female creatives." Despite the challenges, Scott's risks paid off, and after attending comic conventions where she met editors and other creatives, she landed her first gig.

"LET'S JUST SAY THAT NICOLA SCOTT IS AN IMPOSSIBLE TALENT. OH, AND AN AMAZING IDEA PERSON. AND A GENEROUS COLLABORATOR. LET'S JUST SAY THOSE THINGS BECAUSE HER ART SLAYS ME EVERY TIME."

—**Gail Simone**, writer of *Birds of Prey* (2004–2007)

It wasn't long before her work was noticed by Gail Simone, who had recently started working with DC Comics, and she recommended Scott for *Birds of Prey*. "No one was more in tune with my scripts than Nicola," said Simone. "She was perfect for me because I would push the envelope on content and she absolutely would catch that pass and run all the way with it without hesitation. Beyond that, she's just a brilliant artist and storyteller and designer, and I was honored to work with her at all." For more than a decade, Scott has been bringing her artistic, storytelling, and designing talents to DC's top titles, repeatedly fulfilling her dream to draw Wonder Woman.

# GAIL SIMONE

"I WOULD NOT BE WORKING IN COMICS TODAY WITHOUT GAIL SIMONE. SHE HELPED ME GET THROUGH SOME VERY HARD TIMES WHEN I WAS STARTING OUT IN COMICS FOR NO OTHER REASON THAN IT WAS THE RIGHT THING TO DO. AND I KNOW I'M NOT THE ONLY ONE SHE'S BEEN THERE FOR."

—**Mairghread Scott**, writer of *Batgirl* (2018–2019)

Gail Simone is one of the most prolific female writers for DC, credited on hundreds of comic issues, including *Wonder Woman*, *Birds of Prey*, *Secret Six*, *Batgirl*, *JLA: Classified*, and many more. Simone's path into professional comic writing was unusual and inspirational. While working as a hair stylist, Simone wrote parodies and essays that examined the roles of female characters in comics. This work was published online and caught the attention of comic editors. Transitioning to comics writing as a career, however, wasn't an easy step for Simone. "I thought because I had a day job and had only been writing for fun, I wasn't a 'real' writer," said Simone. "I had to be dragged by the hair into my dream career." But once she started, she quickly earned a reputation as a top storyteller at DC.

Simone's seminal run on *Birds of Prey* cemented her as one of the most sought-after writers in the business, with her deft talent for writing believable, relatable characters who honor the classic character DNA in clever ways. "If you can present dedicated readers with a new observation about Wonder Woman or a new behavior for Batman, I think it creates a bond, it makes for a little joyful connection," said Simone. On *Birds of Prey*, and later on *Secret Six*, she worked with artist Nicola Scott, who praised Simone: "It was that collaboration experience of working with Gail that really shines through. We really spoke the same language when it came to what we thought was funny, what we felt was smart, what we thought was sexy, what we thought was violent."

Simone's stories often feature diverse casts, and she is the co-creator of Alysia Yeoh, the first major transgender character in the DC canon. "Every con I go to, every bookstore signing I do, I see this incredibly diverse readership, and I took it very personally that we didn't have heroes to point to that looked at least a little like them," said Simone. "Above all, our duty is to tell the best stories we can. That's always priority one. But if we happen to present a hopeful, inclusive message at the same time, that seems very fitting in a world of fictional heroes."

Beyond her contributions to the DC Universe through her writing, Simone has encouraged and helped bolster new talent. "When we were hired to write *Batgirl and the Birds of Prey* we were exhilarated and filled with pure terror. How could we create stories as good or as important as Gail Simone did during her run?" wrote Shawna Benson and Julie Benson, writers of *Birds of Prey* and *Green Arrow*. "We had big shoes to fill, and Gail was a gracious mentor who not only passed the torch to us, but also publicly encouraged her devoted fans to give our run a chance. Gail has managed to maintain a career not only writing characters like Batgirl and the Birds of Prey, but has also left her mark on many popular male superheroes for multiple publishers."

# LOUISE SIMONSON

"LOUISE SIMONSON IS ONE OF MY COMIC BOOK HEROES. SMART AND TALENTED, SHE IS A GO-GETTER WHO HAS NOT SLOWED ONE BIT OVER THE YEARS. SHE CONTINUES TO INNOVATE AND TRIES NEW THINGS."

—**Marie Javins**, executive editor at DC

Louise "Weezie" Simonson began writing and editing comics in the mid-1970s. In 1991 she brought her talents to DC, where she would write some of the company's most successful titles. Her adventure began with *Superman: The Man of Steel*, a title she would write for over eighty issues. In 1992, Simonson was involved in crafting and writing the "Death of Superman" storyline and created the character Steel, who she wrote in thirty-one issues of his eponymous comic. She has also written Wonder Woman comics and Justice League novels.

"I was reading comics in the very beginning," Simonson recalled. "When I was a little kid, the comics that I got were off the spinner racks at Walgreens. There weren't comic book shops." Despite her childhood love of comics, her career path didn't lead her directly to the industry. "I was working in advertising promotion, and I had a friend who worked for a comic book company and she said, 'There's a job opening and you can do it. It pays better than your job.' And I said, 'Okay, I'll apply.'" From this modest beginning, Simonson would go on to earn a reputation as one of the best superhero writers in the business.

With her innovative spirit, Simonson has distinguished herself as a master storyteller. Though her stories are inventive and original, Simonson approaches them simply, beginning with the character. "I prefer character-driven stories over plot-driven stories," said Simonson. "Maybe the most important thing, even more than not boring people, is making characters your readers want to spend time with." Her mastery of character has been noted by those who have worked with her. "Weezie knows almost everything, is curious about the rest, and wants to make you love the characters as much as she does," says Kristy Quinn, editor at DC. "When you throw her a puzzle, she puts it together beautifully and makes the stories sing."

This commitment to character-based stories is seen throughout the "Death of Superman" storyline, which was not only one of the biggest and most memorable events in DC history, but also one of Simonson's favorites. "I loved doing that and I think it was a miracle of continuity!" said Simonson. "It's some of our best work, the whole team's best work. It was very much a team event and it was wonderful."

Simonson has written some of the biggest male heroes in some of their greatest storylines, but one of her favorite characters remains Lois Lane. "I always loved

being able to write Lois," she said. "She had a lot of gumption and that was the Lois that I really admired. I wanted her to be the Lois who'd go out and discover things and be brave and smart and get things done. And she always did."

Beyond her work on the page, Simonson has been influential in the industry. Letterer Janice Chiang recounted that after a brief break from the industry, meeting Louise Simonson was instrumental in reigniting her passion for her career. "When I came back in the 1980s, Louise Simonson was there and I said, 'A woman! Thank God, a woman!' She relaunched me," said Chiang.

Moreover, Bobbie Chase, Vice President and Executive Editor of Young Reader and Talent Development at DC, said of Simonson, "She's just the real deal. She knows everything. She's a fantastic editor, a fantastic writer. She's the whole package of professionalism and creativity." As an all-around creative force, Simonson continues to contribute and make a lasting impact in the DC Universe.

# JILL THOMPSON

Jill Thompson is a multi-hyphenate, multiple Eisner Award winner, and one of the earliest female artists to draw the flagship *Wonder Woman* series. "I have always wanted to draw comics and stories from the time I was a little girl," said Thompson. "I followed my love of comics from a hobby I spent time doing on my own to seeking critique and advice at conventions. Next, taking that advice and going to art school to learn the fundamentals of drawing and perspective and design, anatomy, color theory, composition and applying them to the comic format."

"MY SUPERHERO WRITING IS DEFINITELY INSPIRED BY JILL THOMPSON, SPECIFICALLY HER AMAZING [GRAPHIC NOVEL] *WONDER WOMAN: THE TRUE AMAZON*, WHICH COMBINES THE MYTHIC AND THE HUMAN SO PERFECTLY, IT'S ENVIABLE."
—**Mariko Tamaki**, writer of *Supergirl: Being Super* (2016)

Thompson's work for DC has spanned nearly every facet of comic-making, including writer, interior artist, cover artist, colorist, and letterer. According to Thompson, each role is important in "creating a mood, evoking emotion or a response from the reader. . . . It's a delicate balance, and each part compliments the other if done thoughtfully." In addition to Wonder Woman—a character that

she began working on in 1990 and returned to with 2016's *Wonder Woman: The True Amazon*—Thompson's creative output with DC can be seen in her influential *Swamp Thing* and *Sandman* runs.

# DOROTHY WOOLFOLK

In 1942, Dorothy Woolfolk (*née* Roubicek) began editing comics for All-American Comics, the company that originally published titles such as *Wonder Woman*, *Flash Comics*, and *Green Lantern* and would later be merged into DC Comics. During her pioneering tenure, Woolfolk worked as an assistant editor on *Wonder Woman* and was the one of the few women in the industry.

In the early 1970s, Woolfolk returned to DC to do some of her most notable work as she edited the so-called "girls' books," which included the romance line in addition to the *Wonder Woman* and *Superman's Girl Friend, Lois Lane* series. Though many male editors at the time looked down at the romance line, which included titles like *Falling in Love*, *Girls' Love Stories*, *Girls' Romances*, *Heart Throbs*, *Secret Hearts*, *Young Love*, and *Young Romance*, Woolfolk used the line to elevate feminist themes, creating leading ladies with complexity, nuanced personalities, and agency.

"SORRY, SUPERMAN! I'M NO LONGER THE GIRL YOU COME BACK TO BETWEEN MISSIONS. I CAN'T LIVE IN YOUR SHADOW—I'VE GOT THINGS TO DO!"
—**Lois Lane**, *Superman's Girl Friend, Lois Lane* #121 (1972), edited by Dorothy Woolfolk

But her feminist contributions to comics didn't stop there. From her first issue on the Lois Lane book, Woolfolk challenged the status quo and broke ground for the hero. Under Woolfolk's supervision, Lois became a fully realized character. She would take charge of her life by becoming her "own boss" as a freelance writer and breaking up with Superman. Woolfolk ensured that Lois moved beyond stereotypes to become a complete hero who could hold her own as she fought alongside Superman.

Nearly eight decades after she proved herself as one of DC's first female editors, she would do it again posthumously when she and early *Wonder Woman* writer Joye Murchison Kelly were jointly awarded the 2018 Bill Finger Award—the first female winners in the award's history.

# ABOUT THE ARTISTS

**ANNIE WU** is an American illustrator currently based in Chicago. She is the creator of the upcoming Image Comics series *Dead Guy Fan Club*, a neo-noir black comedy. [pp. 28, 53, 88]

**BRITTNEY WILLIAMS** is a storyboard and comic book artist who draws too much. From Walt Disney Animation Studios to DC Comics, she's worked for an array of animation studios and publishers. As a two-time GLAAD award nominee, she exists to create things for kids and the queer community. [pp. 39, 67, 106, 112]

**COLLEEN DORAN** is the *New York Times* bestselling cartoonist behind *Amazing Fantastic Incredible: A Marvelous Memoir* by Stan Lee and *Troll Bridge* (with Neil Gaiman). Recent works include *Snow, Glass, Apples* (also with Gaiman), *Finality* (with Warren Ellis), the miniseries *The Clock*, the space opera graphic novel series *A Distant Soil*, and illustrations for the Netflix series *Jessica Jones*. Her credits also include *Wonder Woman*; *New Teen Titans*; *Captain America*; and work for Disney, Random House, and Houghton Mifflin. [pp. 15, 80, 91, 118, 128]

**ELSA CHANG** is a Los Angeles–based character designer and illustrator. She graduated from Art Center College of Design with a BFA in illustration, and had training at the Walt Disney Animation Studios. She has worked for Sony Animation, Paramount Animation, Nickelodeon, DreamWorks TV Animation, and is currently at Disney TV Animation. When she is not working or creating art, she enjoys horseback riding and taking care of her pets, which include four pigeons, two doves, two parrots, two cats, three dogs, a fish, a freshwater snail, a tarantula, and a few dozen cherry shrimp. [pp. 31, 79, 120, 133]

**EMANUELA LUPACCHINO** is a longtime illustrator and comic book artist based in Italy. After working on a number Italian comics series, including *L'Insonne*, she has since worked as a penciller and cover artist for IDW, Marvel, Valiant, Dark Horse, and DC Comics. Her art has appeared in a wide range of series, including *World's Finest Comics*, *Birds of Prey*, *Catwoman*, and *Supergirl*. [pp. 16, 84]

**GISÈLE LAGACÉ** is a Canadian cartoonist from New Brunswick. She has worked on various creator-owned webcomics, including *Ménage à 3*, *Eerie Cuties*, and more. She's currently drawing *Exorcisters* (working with writer/co-creator Ian Boothby), published by Image Comics. She has also drawn for Archie Comics, IDW (*Jem and the Holograms*), Dynamite (*Betty Boop*), and many others. [pp. 24, 44, 67, 77, 116]

**IRENE KOH** is an illustrator, wanderer, and red-meat enthusiast. Most recently, she is a professional comics artist (illustrating the *Legend of Korra* graphic novel series) and karaoke superstar. [pp. 42, 87, 115, 125]

**JEN BARTEL** is an illustrator and comic artist who is best known for her ongoing cover work for clients like Marvel, DC/Vertigo, and Dark Horse. She is the co-creator and artist of *Blackbird*, published by Image Comics. [front cover, pp. 12, 94]

**JENNIFER ABERIN JOHNSON** is a Toronto-based game developer, comic artist, and illustrator. She is fascinated with portraying otherworldly landscapes and strives to promote diverse voices in speculative fiction. [p. 73]

**LITTLE CORVUS**, aka Sar DuVall, is a Seattle-based queer, non-binary, Latinx comic artist and illustrator. A graduate of the School of Visual Arts with a BFA in Cartooning (2015), they are an Eisner-nominated artist who has worked with Lion Forge, Abrams, Iron Circus, Chronicle Books, and more. They love street fashion; positive, diverse stories; and the color pink. [pp. 19, 63, 127, 134]

**MINGJUE HELEN CHEN** is a visual development artist and art director currently based in Los Angeles. Her work in film and comics has included clients such as Walt Disney Animation Studios, DC, Marvel, Boom Studios, and others. [pp. 36, 70, 101]

PAULINA GANUCHEAU is a comic artist and illustrator based wherever her computer lives (she moves a lot). She graduated from the Savannah College of Art and Design with a BFA in sequential art. She is the creator *Lemon Bird* and co-creator of the comic *Zodiac Starforce*. Her hobbies include cloud photography, watching pro-wrestling, and following cats on Instagram. [p. 47, 59, 105, 109, 130]

STEPHANIE HANS is an illustrator with a decade-long career in the mainstream comic books industry. After hundreds of covers and pages for DC, Marvel, Valiant, Dark Horse, and many more, she is currently working with longtime-collaborator Kieron Gillen as co-creator on the new Image title *Die*. [pp. 51, 56, 138]

WINONA NELSON is an illustrator/video game concept artist/painter from Minnesota, now based in Philadelphia with her partner and fellow artist Anthony Palumbo and their gentleman cat, Diego. She is a member of the Minnesota Ojibwe tribe. In all her work, she focuses on depicting authentic human and animal diversity and emotion. Clients include Wizards of the Coast, Games Workshop, and Naughty Dog Games. [pp. 23, 33, 74, 98]

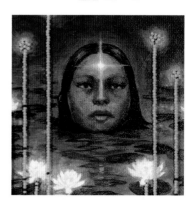

# ACKNOWLEDGMENTS

I would like to thank all the women and non-binary contributors to this book for their input on the characters and creators; the creators who are profiled, and the many, many more who have contributed to the legacy of DC Comics; the behind-the-scenes teams at DC; and the awesome DC fans, who inspired me with their love of these characters.